HOW TO START AND OPERATE A DIGITAL PORTRAIT PHOTOGRAPHY STUDIO

Lou Jacobs Jr.

AMHERST MEDIA, INC. ■ BUFFALO, NY

ABOUT THE AUTHOR

Lou Jacobs Jr. has been writing how-to photography books for decades, and this is his twenty-ninth. One of his chief rewards while researching and writing this book was talking to and learning from many photographers. Their experiences and opinions are imbedded in various chapters. Many excellent photographers have lent their beautiful work to help illustrate this book, and Lou has chosen a fine selection of their images. Some of Lou's own portraits appear in chapter 6. He feels that pictures by other talented photographers are "treats" that are also instructive.

Lou lives in Cathedral City, California with his wife, Kathy. He says that lighting, posing, and talking with portrait subjects are the keys to producing outstanding portraits.

Front cover photographs by: Tim Schooler (portrait) and Frank Frost
 (background images)
Back cover photograph by: Frank Frost

Published by:
Amherst Media, Inc.
P.O. Box 586
Buffalo, N.Y. 14226
Fax: 716-874-4508
www.AmherstMedia.com

Publisher: Craig Alesse
Senior Editor/Production Manager: Michelle Perkins
Assistant Editor: Barbara A. Lynch-Johnt

ISBN: 1-58428-171-5
Library of Congress Card Catalog Number: 2005926584

Printed in Korea.
10 9 8 7 6 5 4 3 2 1

CONTENTS

CONTRIBUTORS

Bill Abey of Ft. Myers, Florida is a Master Photographer, Photographic Craftsman, and a Certified Professional Photographer. During his over thirty-year career he developed a chain of five full-service photo studios in the Youngstown, Ohio area, and he served an additional fifteen years when Lifetouch became the owner. As corporate director of photography he was instrumental in switching the studios' operations to digital. Bill is semi-retired, does photographic consulting and training, and spends part of each month helping create new backgrounds and doing catalog photography for Denny Manufacturing Company, Inc. in Mobile, Alabama. He has been a frequent Professional Marketing Association (PMA) and Professional School Photographers Association (PSPA) speaker. Visit his website at www.abey vision.com.

Robert Arnold of Oakland, California has been a photographer for thirty years. He says, "I've taken hundreds of portraits over the years, many for a fee, and a lot just for the love of capturing faces. My background in graphic design and painting helps me with my portrait images, and I try to keep current by searching for fresh posing ideas. I also try to let subjects find their own natural poses. I paint all my own backgrounds and sometimes add or change the texture during a shoot. Photography continues to drive my creative spirit." To learn more about Robert, access his website at www.robertarnold.com.

Kurt Brewer of Salida, Colorado and his wife Monique operate a modest and efficient portrait studio on the main street of town. Kurt has been a professional photographer for over twenty years, at first shooting weddings from a home base in Buena Vista, Colorado. He shoots senior and wedding photographs and says he watched digital equipment evolve for several years before he was able to buy the quality he could comfortably use. He first experimented by inviting some high-school students for complimentary sittings and was immediately satisfied with his results. He retouches selected images and is a popular guy with seniors. Visit his website at www.wildirisstudio.com.

Laura Cantrell operates a thriving studio in Mobile, Alabama and specializes in children. With her sister Lisa she inherited the studio from their father, after

apprenticing for a while shooting portraits. "My father trained me," she says, "and I also credit the Professional Photographers of America (PPA) and numerous seminars over the years." In time she phased out shooting weddings to concentrate on children's portraiture. Laura promotes her studio with mailers and via a "baby plan" through which she photographs the first five years of a child's life. The studio on two floors features floor-to-ceiling windows facing south, and she also shoots in a courtyard that receives soft north light. Lisa handles the presentation part of their business and says her sales style is "based on a true passion for beautiful portraiture." Her web address is www.lauracantrellphotography.com.

Anthony Cava and his brother Frank own and operate Photolux Studio in Ottawa, Ontario, Canada. Theirs is a second-generation studio where Anthony works mainly in the wedding and portrait spheres. At age thirty-one he was awarded a Masters of Photographic Arts designation, one of the youngest Canadian photographers to receive it. In addition he is the only Canadian, and one of only nineteen individuals in the world, to hold the prestigious title, Accolade of a Lifetime of Photographic Achievement. Anthony's images have been shown in many photographic magazines and in three books published by Amherst Media. In his lectures he discusses the real challenges of running a studio, along with his philosophy of the business in general. Visit the Cavas' website at www.photoluxstudio.com.

Tommy Colbert of Brockton, Massachusetts did photography in high school, and at age eighteen was running a Microfilm company darkroom, where he also processed his own photographs. He moved to New York at twenty-one and worked briefly in several studios until he became a personal fitness trainer. He trained Jane Fonda years before she wrote her first fitness book. Quite successful, he juggled fitness training with photography. Eventually he moved to Boston and began shooting photojournalistic weddings and now has a widespread clientele. Tommy works from a studio and office at home and may shoot several weddings from Friday through Sunday. Visit his website at www.tommycolbert .com.

Brian K. Crain of Baton Rouge, Louisiana studied at Louisiana State University then joined the Navy where he was a photographer for five years on two aircraft carriers. After an honorable discharge he worked at a studio photographing sports, seniors, and weddings. At that time wedding coverage was traditional, but when digital capture was available, Brian was fascinated with its potential. He left the studio and opened his own business where he says, "After doing a few weddings I realized that I could incorporate a sense of fashion in wedding photography and bridal portraits. Brides started to take notice, and I've

traveled to places like New York to work with couples who admired my work." Brian also does editorial fashion assignments. For more information, visit his website at www.bkcphoto.com.

Dina Douglas of West Hollywood, California bought her first professional camera at age twelve and began to document the world. Later she studied photography at three universities and earned two journalism degrees. Working for magazines and newspapers, she won numerous awards for photojournalism. Since she turned her artistic eye toward capturing the joy of weddings, Dina has gained a reputation for catching unique moments with a romantic style. Her photographs have appeared in *The Knot Weddings, Inside Weddings, Los Angeles Times,* and on MTV. Her documentary work with early 1980s punk rock musicians will be featured in *Punk's Not Dead: The Movie* in 2006. Visit her website at www.andrena.com.

Rick and Deborah Lynn Ferro shoot individual portraits and wedding images with style in their Jacksonville, Florida Signature Studio where they work together in the camera room. Their reception room showcases portraits and elegant albums, and they present images by projection in a viewing room curtained off from a high-tech shooting area that can be converted to a classroom for workshops Deborah holds. She is a PPA Craftsman, Rick is a PPA Master Craftsman, and both have Masters degrees from Wedding and Portrait Photographers International (WPPI). The couple will hold workshops in four European countries at the end of 2005 under the auspices of the British PPA. You can visit the Ferros' website at www.rickferro.com.

Rick is the author of *Wedding Photography* (3rd ed., Amherst Media, 2005); Deborah is the author of *Artistic Effects with Adobe® Photoshop® and Corel Painter®* (Amherst Media, 2005); and together the couple has authored *Wedding Photography with Adobe® Photoshop®* (Amherst Media, 2003).

Frank Frost of Albuquerque, New Mexico discovered his love for photography in junior high, and at sixteen he photographed his first wedding. After high school he worked at McDonald's to save money for a studio, and at age twenty-two he bought a mom-and-pop studio. He continued to manage a McDonald's and started studio appointments in mid-afternoon. After two years he said goodbye to the restaurant. Today in a far more elaborate studio Frank has become a family portrait specialist. He employs a staff of seven in surroundings he and his wife Cheri designed to give clients a sense of "home." He does all the studio's photography with a friendly attitude that attracts children, brides, and teens. Frank's web address is www.FrankFrost.com.

Doug Jirsa and his wife Donna operate a flourishing portrait studio called Lasting Impressions on a main street in downtown Redlands, California. Their

business is approximately 50 percent seniors, with the remainder divided between family, children's, and adult portraits. At one side of the studio is a 19-inch monitor to view images he's shot. Doug makes "Quick Proofs" (see page 99) and Donna later makes whatever Photoshop improvements are needed. He suggests, "To make a business successful you need to be a good photographer and a canny businessperson. Learn by working in another's studio till you have the confidence to start your own." Visit the Jirsa studio website at www.lasting impressionsfoto.com.

Brian King began attending classes at Columbus College of Art and Design in Ohio when he was in grade school, and he worked in various media. He studied photography in high school, then enrolled at the Ohio Institute of Photography. "Though I didn't have much interest in portraiture," he confesses, he took a job photographing high-school seniors at Cubberly Studios in Delaware, Ohio, and after graduation he became a portrait expert. He was a top shooter at Cubberly Studios for ten years and worked to polish his techniques and experiment, as some of his photographs in this book show. "Develop good relationships with your portrait subjects," he advises, "and they'll be back."

David LaClaire of Grand Rapids, Michigan joined his father Maurice in his established portrait studio as a young man in 1950. Maurice already had national recognition, and the studio had its own elaborate color print lab. David followed a tradition and taught color portraiture at Winona, became a partner in the studio, and eventually took it over when Maurice retired. In 2003 a handsome book, *Photographic Portraiture by LaClaire* (LaClaire Portraiture, Inc., 2003), was published. The book shows a diversity of LaClaire portraits, including affluent families at home, mothers with children, and others. They also photographed President Gerald Ford often over the years. Examples of the LaClaire style of portraiture appear in this book, and David continues to take sittings on a limited basis. Visit the LaClaire studio website at www.laclaire.com.

Roy Madearis' studio is known in Arlington, Texas and vicinity, partly because of his partner–wife's "Watch Me Grow" plan, which provides yearly children's portraits at reasonable rates. Roy wanted to be his own boss when he studied business at the University of Texas, but he was attracted to a museum darkroom class, which led to being hooked on photography, and he later shot weddings for friends. He also worked at a bank, practiced his business skills, and eventually opened a studio in downtown Arlington. He says he had little portrait or wedding experience then, but taking classes for over a dozen years helped make him a specialist. Today he's expanded to his third studio in a historical old home and is successful enough to be open only Tuesday through Friday. Visit the couple's website at www.maderais.com.

Stacey Magnuson owns and operates Gentle Portraits, a digital studio specializing in portraits and weddings, in Colorado Springs, Colorado. Her work is journalistic in nature, and she captures lifestyle events as they occur to create a visual story. Mentored by film and digital photographers in the United States and abroad, she suggests, "Find an organization or forum to join where you can learn from each other. Fellow photographers understand your situations." Stacey exerts her personality to draw out the essence of her clients in meaningful portraits and serves as an online moderator for the international Digital Wedding Forum. Her web address is www.gentleportraits.com.

Glenn Rand received his Bachelor in design and Master of Arts in industrial design from Purdue University with a Doctorate in education from the University of Cincinnati. Photographs by Dr. Rand are in the collections of over twenty museums in the United States, Europe, and Japan. He has published and lectured extensively about photography and digital imaging, ranging from commercial aesthetics to the technical fine points of black & white imagery. Dr. Rand teaches in the graduate program of Brooks Institute of Photography in Santa Barbara, California.

Roger Rosenfeld has been in business since 1982, and during that era has produced high-quality photographs for ad agencies, designers, and business firms. His studio in San Rafael, California (about fifteen miles north of San Francisco) specializes in images of products such as food and wine. Roger graduated from the University of Pittsburgh and studied at the New York Institute of Photography, the School of Visual Arts and Fashion Institute of Technology in New York. He was head of the photography department at ArtWorks in San Francisco. Roger also runs www.clickwebservices.com, where he designs classy websites for photographers and other professionals.

Tim Schooler of Lafayette, Louisiana was a district manager for the Maytag Corporation for a number of years before he decided to turn his passion for photography into a portrait business. Now he offers portraits and wedding coverage, but his main clientele is high-school seniors, a specialty for which he has a fine touch. He also shoots outdoors in favorite locations that his teen clients enjoy. He says, "I use available light and reflectors along with gobos and/or scrims to re-create directional studio lighting on location." He has an instructional DVD in the works that originated from his workshops on portrait lighting. Visit his website at www.timschooler.com.

INTRODUCTION

I'm amazed that photography has evolved so far, so fast. Consider Gustave Gray, who opened a portrait studio in Paris in 1858, where a modern photographic curator says he made "fine and dramatic portraits." Imagine using wet plates coated a few minutes before exposure. Try to imagine how astounded Gray would be today if offered film or a digital camera or electronic flash for his portraits. Of course, the evolution has taken 147 years.

Most photographers tell me that going digital, replacing negatives and slides with memory cards, has been a real business boost. During a transitional period when you may have shot some film while practicing digital, the switch seemed novel. By now, you may have found that the digital camera and process inspires you to be more creative. A couple of photographers have reported, "Once I got into digital, I never looked back." Not fussing with negatives—and seeing images a few seconds after an exposure—is a welcome form of instant gratification. It gives you confidence to rethink and reshoot. Most photographers say their photography and income have improved.

> "The aim of every artist is to arrest motion, which is life, by artificial means, and hold it fixed so that 100 years later, when a stranger looks at it, it moves again, since it is life." —William Faulkner

If you now run a portrait and/or wedding studio and shoot film, you'll find that going digital is a positive evolution that will improve your photographic attitude. You can still light and pose to suit your taste, but postproduction work will be different. For example, negatives won't be

Image by Frank Frost.

lost or scratched. CDs full of pictures are easy to store and project. Basic camera work, composition, and timing, for instance, won't change much. But digital image enhancement by computer should be personally satisfying to you and your clients. You will continue to make clients

Image by Dina Douglas.

happy, but with digital, it should be more fun. People are still fascinated by the digital process, and they will be intrigued with your professional approach. They may take their own digital pictures, but they are still primarily snapshooters.

During a transition to digital, be patient and be bold. Be patient when you try new digital techniques, and be bold by experimenting with possibilities. Be patient during the postproduction learning process. You may be tempted to show clients how they look after making a few exposures, but it's usually wise to wait longer, because stopping to share upsets your rhythm. Take advantage of studying the LCD finder on the back of your digital camera to confirm lighting or whatever. Better yet, as described in future chapters, wire the camera to a nearby computer monitor, then arrange breaks to view enlarged images with clients.

Unwanted poses are deleted and choices are made. To men, women, and teens you seem a very cool photographer.

○ EVOLVING

If you are moving from another kind of business into photography, for hands-on experience, apprentice yourself to a working pro and absorb everything you can. On-the-job training will be valuable. If your digital studio is young, feel good that you have made a wise decision. Digital

Image by Frank Frost.

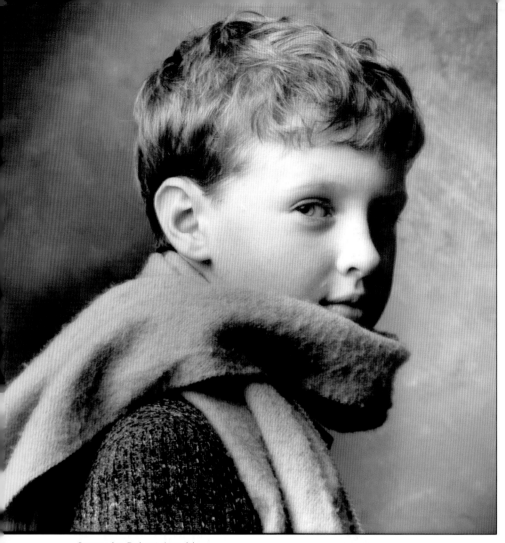

Image by Robert Arnold.

photography helps you relate more closely with the camera, and your enthusiasm increases.

Adopt ethical business practices to please your clients. Keep careful business records, promote your studio, take care that important business arrangements are in writing, maintain a suitable pricing system, and make sure the ambiance of your studio is appealing. Portrait photography can be very stimulating, and digital can boost the sensation.

For the benefit of your portrait studio, or that of a potential photographer who will take you under their wing, talk to photographers with

digital experience as you get going. Chat with professional lab personnel who are handling your photographic workflow. A good lab can relieve you of having to absorb a lot of computer techniques, especially if you learn as slowly as I seem to. Absorb wisdom from others. Your apprehensions will fade away. You won't look back.

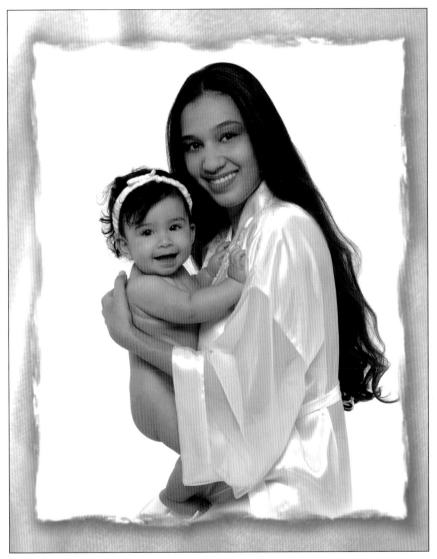

Image by Doug Jirsa.

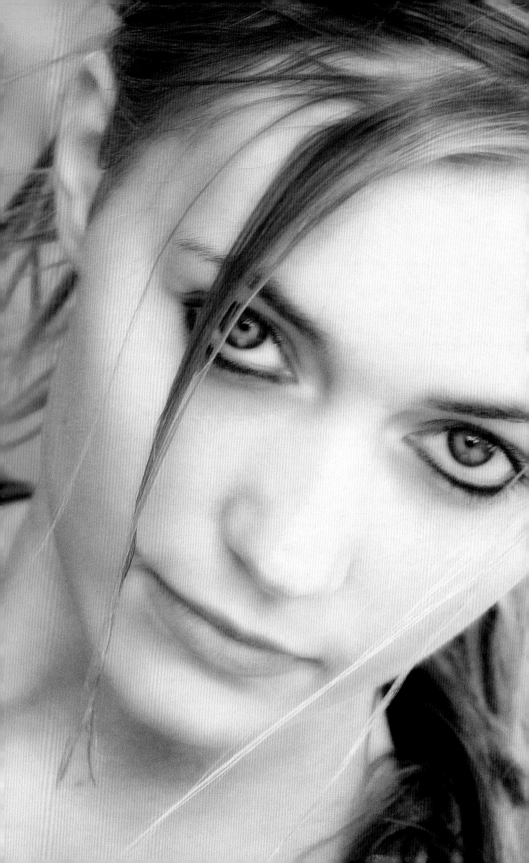

1. THE STUDIO BUSINESS

○ GOING DIGITAL

Switching from film to digital is a professional decision. You should be convinced that it's right for your studio or will be. If going digital doesn't seem financially or photographically comfortable, consider the alternatives. Your present and future clients won't mind if you stay with film. You have to envision becoming profitable enough to make the investments that digital requires. Talk to a business advisor or to a successful colleague who is enthusiastic about shooting digital portraits. And read on for some advice.

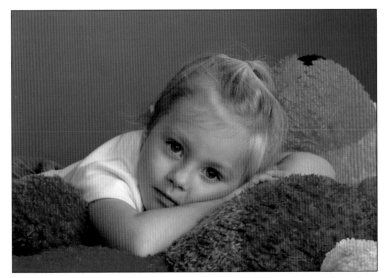

ABOVE—Bill Abey made this lovely portrait for Denny Manufacturing, Company Inc., a business that sells a variety of backgrounds and props. A softbox was the main light. FACING PAGE—Brian King is popular with seniors because his poses are inventive and he elicits appealing expressions from his subjects. This was taken outdoors adjacent to the studio in bright shade.

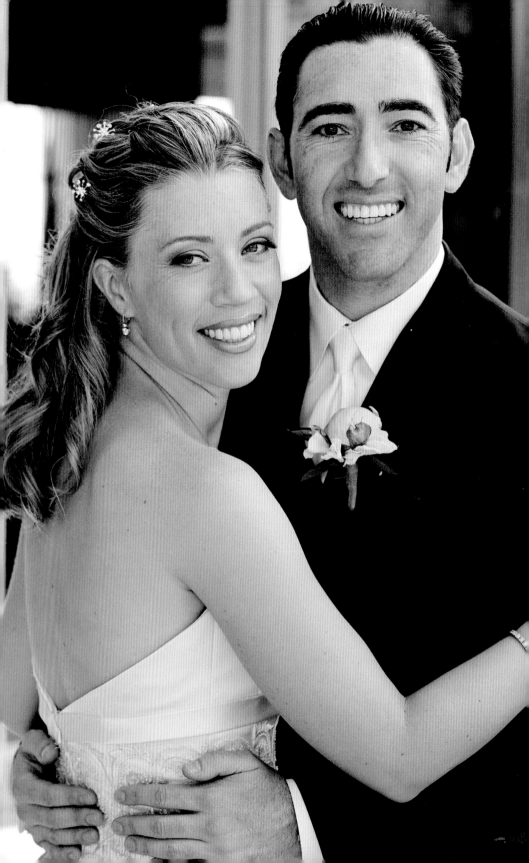

Once you are shooting digital pictures routinely, you'll likely be satisfied that you've made the switch. I haven't met any portrait photographers who regret that they left film behind.

○ PERSONAL CONSIDERATIONS

Hopefully you enjoy interacting with people, because it's a requirement for a flourishing business. This may sound obvious, but time spent getting acquainted and being cordial with portrait clients pays off in good will and repeat business. Successfully shooting portraits and weddings requires psychological sensitivity, and insightful photographers are good directors behind the camera. Your enthusiasm can be contagious.

In his fine book, *The Business of Studio Photography* (Allworth Press, 2002), Edward R. Lilly offers a list of characteristics to boost success in studio photography. I've adapted his list and added to it:

> Take pride in your work and in being a professional.

• Appearance counts. How you dress and groom yourself, along with your attitude, affect how others see you.

• Take pride in your work and in being a professional. Motivation is generated by pleasing people with your pictures.

• Self-confidence is a requisite. Have faith in your photographic skills, in your studio and equipment, and in your ability to handle yourself, especially when your business is (temporarily) not doing so well.

• Empathy counts. Your interest in the lives of your clients helps create a bond. Clients respond well to personal attention that's real.

• Cultivate your ability to overcome fear of rejection. Don't take rejection personally. In business, fear is the enemy.

• Don't be apologetic when you charge proper fees for your creative efforts.

FACING PAGE—In the wedding photography business you sometimes have to capture portraits quickly when you use a photojournalist approach such as Dina Douglas does. The result is real spontaneity.

- Continuous education counts. Be eager to learn more to make your business more profitable. What you read, seminars you attend, and wisdom gained from personal contacts all help build success.

Be eager to learn more to make your business more profitable.

- Enthusiasm counts. Clients will appreciate the way you relate to them while you photograph them. Your positive moods can be infectious. Understand that some of your personal energy comes from healthy hemoglobin, but it's also psychologically generated. Positive thinking boosts energy.
- Give attention to new ideas and techniques. They may be strange or unfamiliar, but consider them all to find one that's a winner.
- Take a positive stance about change. If your photographic experience has been with film, switching to digital can be as gradual or quick as you choose. Talking to colleagues and reading about digital technologies should convince you that shooting digitally will stimulate your enthusiasm.
- Enjoy your achievements.
- Be flexible. When a process, technique, or material doesn't work because it's not popular enough with clients, switch to an alternative. This is another place where talking to professional colleagues can help you make changes wisely. Flexibility helps streamline your business and photography operations.
- The business part of a studio can be interesting and challenging. Be conscientious about it as you grow as a photographer.

I've always liked this axiom: The future belongs to those who prepare for it.

○ CREATIVE EXPERIENCE

Success is generated through maintaining and exhibiting a positive personality, diligent work, creative imagination, and willingness to try new

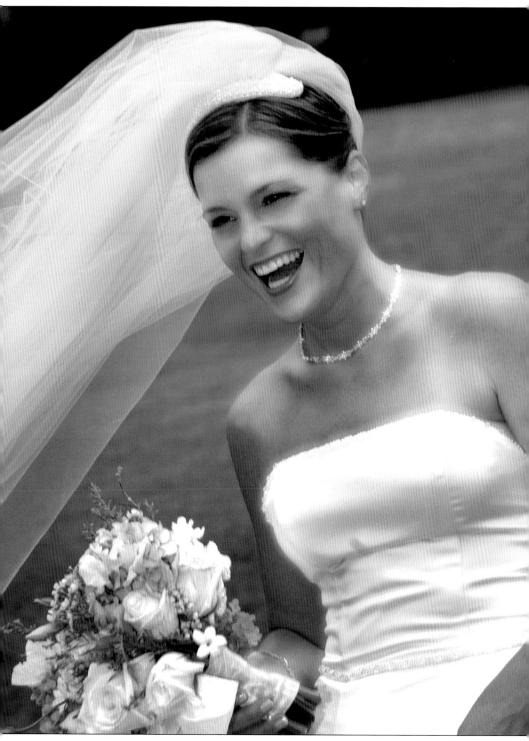

Tommy Colbert looks for fresh, storytelling situations coupled with delighted expressions on the faces of brides, whose weddings he enjoys photographing.

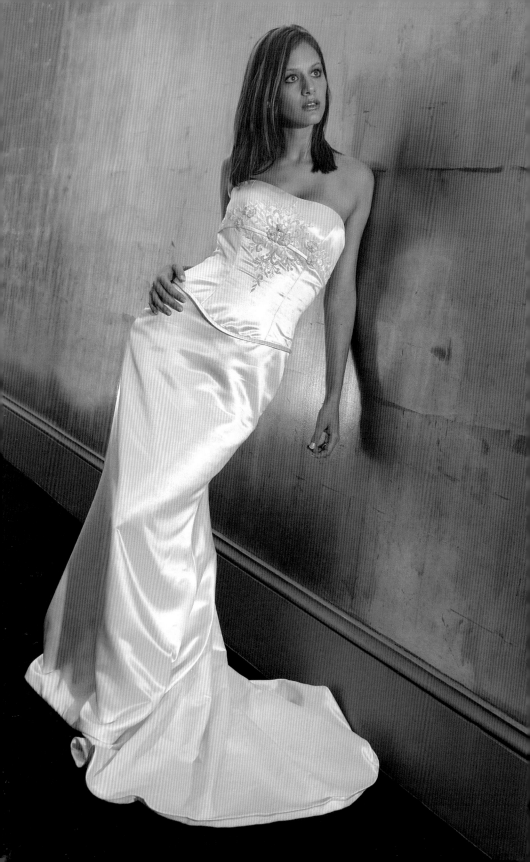

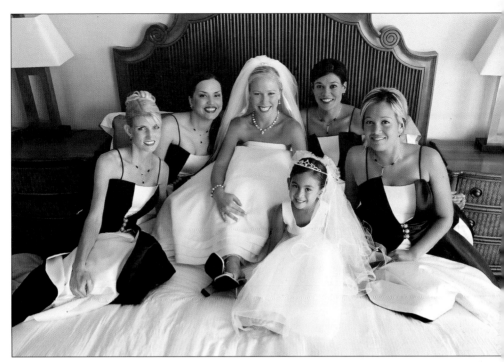

ABOVE—When Dina Douglas photographs a wedding she may arrange groups like this of a bride and bridesmaids on a bedroom floor using natural light and soft flash fill. FACING PAGE—Brian Crain did a fashion-inspired shoot in an interesting setting. His wedding and fashion business include a lot of location shooting.

techniques, equipment, and promotions. In your crystal ball the future should look more prosperous than the present. To boost your enthusiasm, make business decisions that have long-range validity. Mix the powers of creativity into your goal projections. Approach each new sitting with joy in your camera work to help drive studio success.

"Creative" and "creativity" are significant words that I feel are too often used superficially. Try to give creativity real meaning when you tackle visual and business decisions. Enjoy being confident in yourself. Position lights, chat with your portrait subjects, and rejoice in digital portrait advantages. Relate to clients with zest, called cool nowadays. Men, women, and children will be pleased and will come back. Personal pleasure boosts business, and portrait and wedding photography can be a force in your life and community.

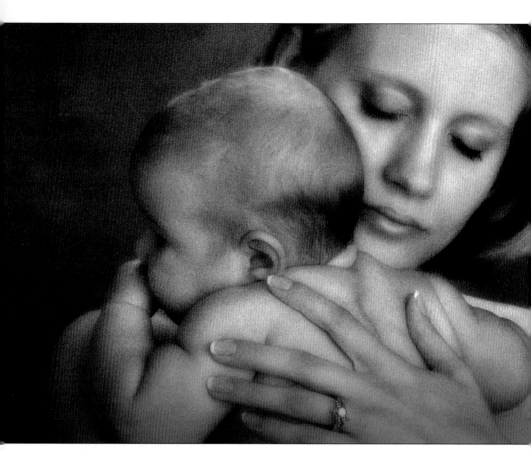

"Mother and child" is a popular and emotionally grabbing mode of portraiture, and Frank Frost excels in this slightly diffused image. He usually has assistance when photographing "little people who move quickly," as he says, but these subjects cooperated perfectly.

O MAKING A BUSINESS PLAN

In the business section of my newspaper there's a well-known comic strip called *Dilbert,* by Scott Adams, and mention of a recent panel seemed appropriate for this chapter. One character is standing, the other sitting at a desk. The standing figure says, "We only have two people on the third floor. Let's move them to our empty cubes here and sublet the [third floor] space." The seated man responds, "Write a business case with all the risks and business drivers and I'll consider it." The standing man says, "I changed my mind. We shouldn't do anything." To which

his boss says, "I need a business case for that, too." I assume that "case" means "plan" in Dilbert language. The boss's response is typical of Scott's comically absurd business themes, and my point is: a digital portrait studio needs business plans as a guide to success.

If you have been in business for a while and already have in place a successful plan for growth you can skim through this. However, if you feel your approach to the business of portrait photography is worth reviewing, this chapter may help you sharpen your focus for the future. A useful business plan covers personal goals, studio space, employees, equipment, overhead items, new techniques, and financial growth.

○ ESTABLISHING A BUDGET

To begin, estimate a monthly dollar amount for each of your business expenses. Multiply the total of all monthly business expenses by 12 for a view of your average yearly outlay. When you have these dollar figures, think about what changes might help you continue to operate an even more profitable portrait studio. If you are about to open a studio, know the numbers beforehand.

Analysis. Based on monthly outlay, decide how much the studio needs to gross monthly to cover labor and recurring expenses. Can you meet your business needs and make a profit? Or, do you need to rethink your business to increase income?

Here's what photographer Kurt Brewer of Salida, Colorado told me: "Monique and I sit down at the beginning of each year and analyze our lab charges, rent, insurance, and other expenses. We factor all these along with an hourly rate we pay ourselves, and the results become the

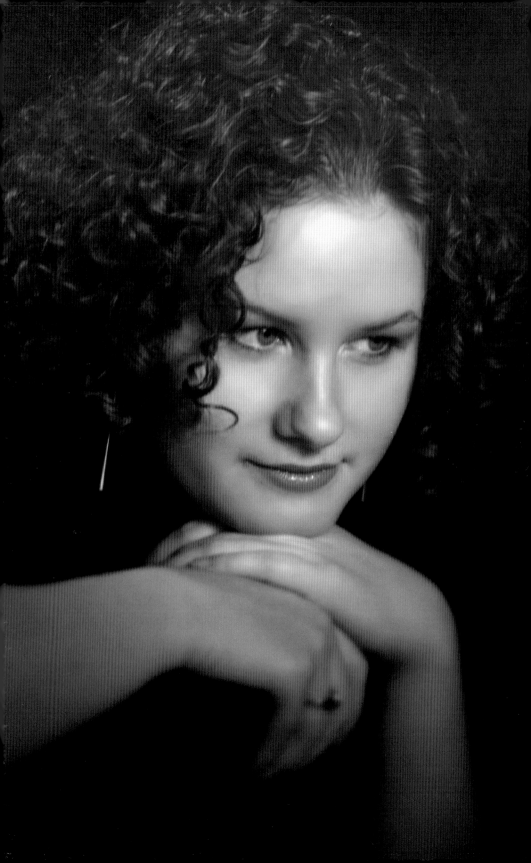

primary basis for viewing our business progress and for setting prices. Additional labor time and material expenses indicate we'll have to raise what we charge for basic prints and packages."

O STUDIO EXPENSES

If you borrowed money to start a digital studio, there may be monthly loan payments to make when you also want to buy a new piece of equipment or start a new promotion. Examine your income vs. your expenses and decide how much profit you can invest in improvements. For all spending you'll need a budget as a guide. Keeping track of your income and expenses indicates when you have a profit. It's less stress to have good business records than to guess and pray. The following are some of the expenses you'll need to cover as a studio owner.

Equipment. Going digital means you need to budget for new cameras, new or enhanced computers, an image-editing program, perhaps a film scanner, and maybe a new printer. These are the principal expenses faced as part of converting to digital.

> It's less stress to have good records than to guess and pray.

Make an effort to save and segregate funds weekly or monthly. If the money is not separated, you risk spending it before the future arrives.

Overhead Items. These include rent or mortgage payments, capital goods and studio repairs, utilities, telephone and Internet connections, advertising, charges for printer inks and paper, lab charges, computer instruction, business vehicle mileage to weddings, postage, repairs or replacement of broken or outdated equipment, various taxes, occasional food for overtime meals, and entertainment such as dinner for a lucrative client who lives in another town. I expect you will also consider items I've forgotten.

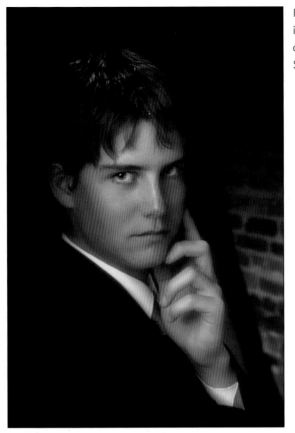

Kurt Brewer photographs in his second-floor studio on the main street of Salida, Colorado.

Employees. If you work with your wife or husband, or have an employee or two, you may have someone to handle your business obligations while you're shooting. If you work alone, you may realize that to make the most of your time behind the camera you need help. By employing others in the studio, you'll have more time to shoot. For example, a woman I talked with recently has one full-time employee who is able to shoot pictures but also does necessary office work. This studio owner told me, "I also employ several part-timers who stuff envelopes for promotional mailings, fill orders, etc., so I have more flexibility. I'm encouraging a young woman in my crew to study photography and to apprentice here in the studio until she's ready for more responsibility."

Because it takes time and patience to train someone with ability and motivation, to help expand your business sooner, consider adding an

associate photographer who may already be shooting digitally. A good way to find someone is to contact photographic schools or colleges that teach photography and explain your needs. Another photographer often comes aboard as a salaried employee.

Employees have to be paid regularly, so budget for them according to the kinds of work they do. You and your wife, husband, or associate in the business also need to be paid on a regular basis as part of your overhead. If you don't need the money, put it in your for-the-future account.

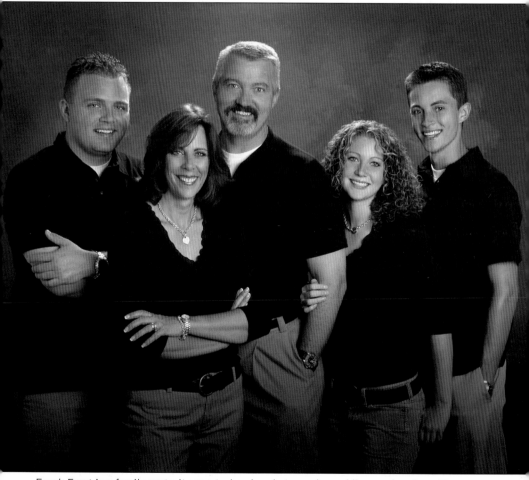

Frank Frost is a family portrait expert who also photographs weddings and seniors. His studio décor is traditional and unpretentious, with plants and a red-brick floor that gives clients a sense of "home."

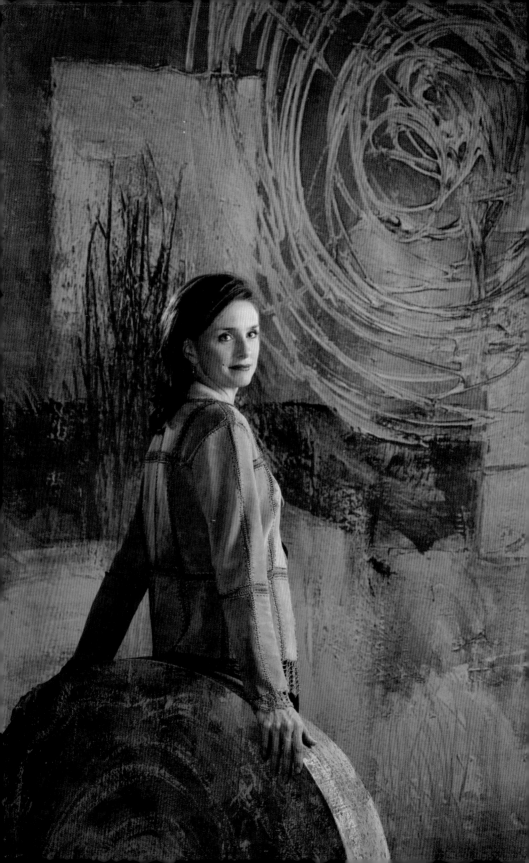

○ ENCOURAGE
A THRIVING BUSINESS

Success in business generates profits that allow you to expand, update equipment, and pay yourself more. Awareness of good business practices is essential to success. Here are ways to encourage a thriving business:

FACING PAGE—Bill Abey posed the young lady in a studio with a decorative background for a Denny Manufacturing Company, Inc. catalog shot. When you offer clients a choice of backgrounds it can help stimulate their enthusiasm and boost business. ABOVE—Laura Cantrell is an expert at making children happy, with the help of her sister Lisa to ensure those angelic expressions. Laura and Lisa have grown the studio considerably with careful business plans and skillful promotion.

- It is important to keep relatively simple records of your business, preferably in a computer program. That waiting file will encourage you to make regular entries. If you only have time to record sales, expenses, etc., in a handwritten ledger at first, transfer the information to the computer a.s.a.p. Accessing your business finances quickly is essential to good practice. Sales, expenses, and sales taxes recorded on the computer are easy to total at the month's end. Careful sales records also help you plan future promotions. When you make entries about sales, you might include notes like, "shot during spring promotion, photographed the whole family." It's too easy to forget people who might become regular clients, so keeping notes about individuals and groups will refresh your memory.
- On the computer, enter your expenses in separate categories such as rent or mortgage, office supplies, employee salaries, phone and utilities, repairs, trade magazines, etc. Later, it's easier to give your accountant all the numbers needed to check profit and loss and

compile income tax records. Be thorough because neglected expense data means you'll pay more income tax.

- Keep receipts for all deductible merchandise and services in separate labeled envelopes or files. If you ever have to document your deductions, you'll be glad you have all those pieces of paper that confirm your honesty.

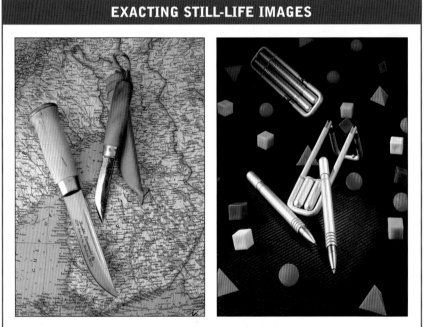

2. DIGITAL CAMERAS

○ CAMERA SYSTEMS

Single-Lens Reflex (SLR). Digital single-lens reflex cameras are the number-one choice for most professionals. If you have been using a high-end 35mm film camera, a same-brand digital model will feel familiar and may accept the film-camera lenses you already have. In the SLR category, then, converting to digital can mean just buying a new camera body and learning how to use it.

Professional digital SLRs have the best features you are used to on film cameras, plus more that are indigenous to digital technology. Many

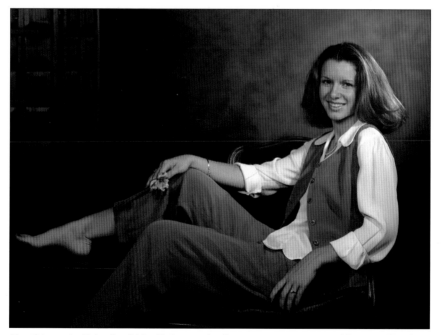

For this portrait by David LaClaire, a glowing young woman posed in a studio chair holding a flower. The main light was a large softbox with two flash heads.

can capture three or more pictures per second. This can be a spectacular way to freeze fast action in existing light at weddings.

Prices vary for digital SLR cameras bodies according to models and brands. Research the cameras that interest you and compare their features. Affordable models include all the controls you need in the studio. SLRs are made by Canon, Fuji, Mamiya, Nikon, Konica/Minolta, Olympus, Sigma, and Sony. Some manufacturers are now producing redesigned lighter-weight lenses especially for digitals. Look at these too when you're in the market.

Zoom-Lens Reflex Cameras (ZLRs). These are single-lens reflex bodies with nonremovable lenses. They include many professional features and offer 6MP or 8MP image sensors—or more. A built-in zoom lens with a focal length from about 35mm to 350mm can be versatile for studio portraits and weddings. Be sure the camera has a hot shoe to accommodate a flash or a device to trip an off-camera strobe. Top-rated ZLR cameras are less expensive than SLRs. For more information, check websites for Fuji, Olympus, Nikon, and Sony, then check out the various models that appeal to you in camera stores.

Medium Format. If you own a medium format film camera, you can buy a digital back that will allow your studio to make the digital transition with the same lenses used for film. Some camera backs offer larger sensors than others, but even the smaller 24 x 36mm sensors may be rated from 12 to 16MP, to make very sharp enlargements possible.

AN EVOLUTION IN COMFORT

In his book titled *Professional Digital Portrait Photography* (Amherst Media, 2003), author Jeff Smith says, "There's nothing more liberating than handholding a 35mm-type camera during a session after being tied down to a medium-format camera and a large camera stand for years." For some studio photographers, digital has been an evolution in comfort.

FACING PAGE— David LaClaire photographed his good friend Rev. Duncan Littlefare many times. In this portrait he is seen as a thoughtful man, a mien supported by the top lighting and expression.

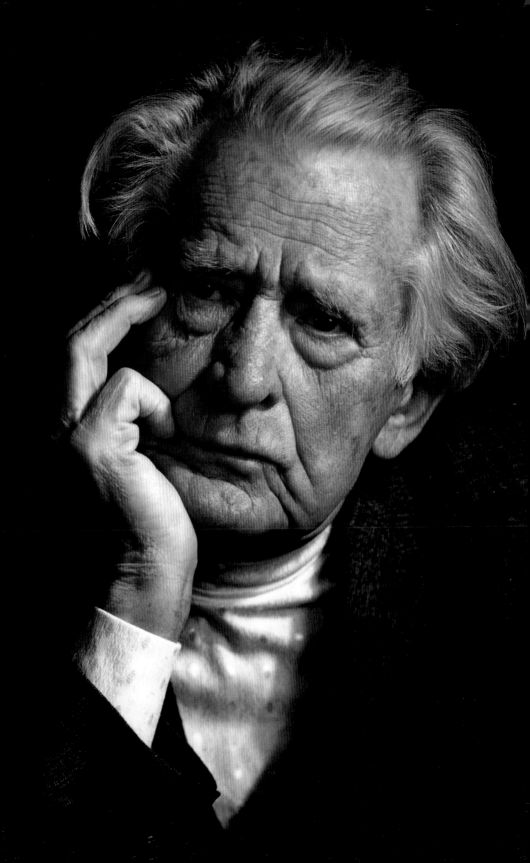

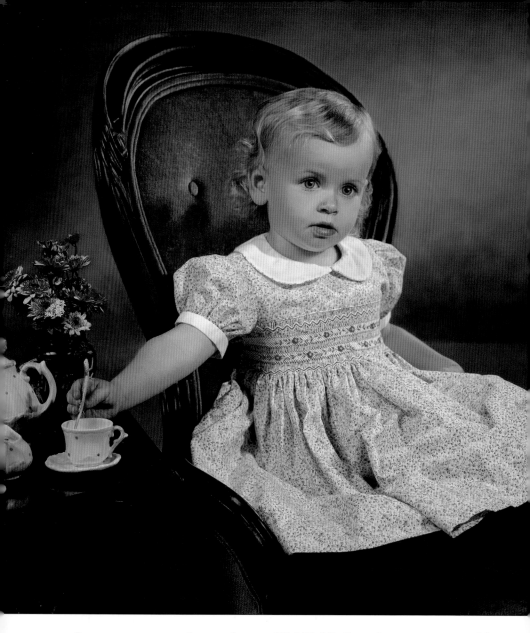

Larger sensors may be rated up to 20 MP. Medium-format cameras with digital backs are mainly for tripod shooting.

Point & Shoot. The compact versions of these digital cameras are unacceptable for professionals because their finders are not precise, and they have no studio strobe connection capacity. Some also suffer from lag time (the interval between pressing the shutter button and the actu-

Here's one more David LaClaire image showing his success in photographing a span of age groups, all portrayed with dark backgrounds that add dignity to the pictures.

al exposure is too long). ZLR digitals with integral lenses are okay for pros because their finders and strobe connections are suitable.

○ COMMON FEATURES

Instant Image Previews. Digital cameras provide the opportunity to see images you just shot by checking the LCD panel on the back of the camera. This great feature enables photographers to confirm composition, lighting balance, poses, and expressions. You can only use the LCD as a finder on compact digitals, not on SLRs, since the reflex mirror is in the way. Immediately after images are captured on an SLR you can see them and review those previously shot.

Adjustable ISO Ratings. Digital cameras make it possible to change the ISO ratings any time a picture situation requires it. Most cameras offer settings of ISO 100, 200, and 400—plus 800 and higher in some models. In the studio with electronic flash, using ISO 100 or 200 can be ideal. When you use hot lights, ISO 400 can be handy. Higher ISO numbers are also useful for outdoor sessions in shade or to stop fast action in sunlight. (Note: The higher the ISO number, the more likely a digital image will show "noise," which is a kind of static pattern that varies considerably according to camera brands and types.)

White Balance (WB). This is the digital term for settings to match the color temperatures of light. Main settings include auto, daylight,

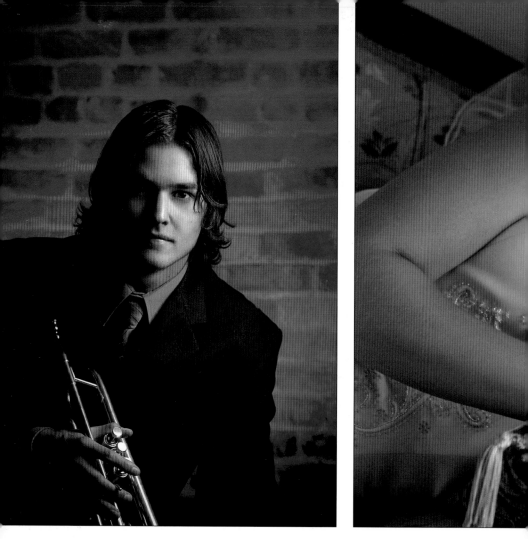

LEFT—A teen subject with his trumpet photographed by Kurt Brewer, who blended red and blue light in the background and used a main light from the side to give the young man an individualistic appearance. RIGHT—Using a zoom lens allowed Brian Crain to stay a reasonable distance from the bride so as not to crowd her. Warm tones give the picture added appeal.

flash, shade, cloudy, white fluorescent, cloudy, and tungsten. Not all those categories may be built into every camera. Automatic white balance may be all you need for studio portraits. For weddings in artificial light or shade you can adjust the white balance to achieve warmer flesh colors. Shoot some comparison pictures to understand how different set-

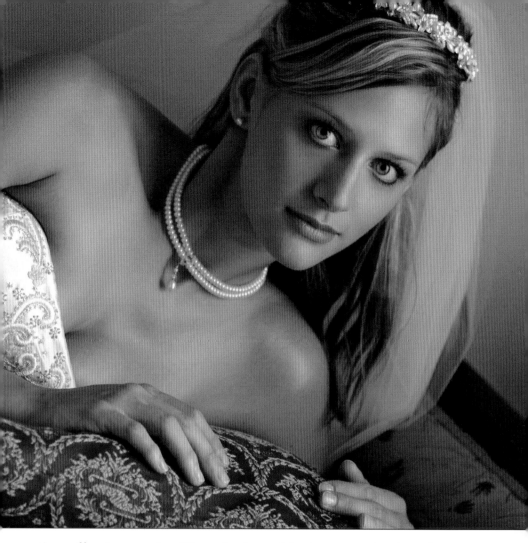

tings affect image color. If you don't need further correction in a photo editing program, you save time.

Histograms. To achieve a pleasant balance between the highlights and shadows in a photograph, check individual exposures in the camera's rear LCD screen where the camera offers a graphic "view" of light variations with a histogram of each exposure. A histogram is a graph of all of the tones in the image. This view and your flash meter reading aid your getting suitable light balance. I've found that judging light contrast visually is usually adequate, but checking histograms is another option. Photographer Doug Jirsa (profiled in chapter 5) has a contrary view. He

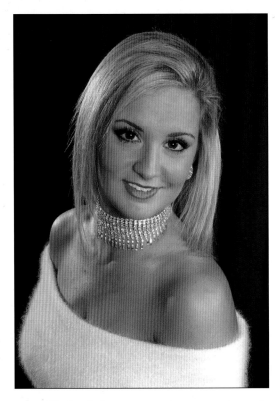

LEFT—Brian Crain used a warm gel on the back light but kept his camera's white balance on an electronic flash setting. The portrait was part of a series he did of a model for his website and for her portfolio. FACING PAGE—We don't know if the tattoos are real or not, but Anthony Cava gave the young man a look of authenticity with strong side lighting. The subject appears in another pose in chapter 9.

says, "I don't know any shooters who take much time to look at histograms. My camera system is tethered to a computer screen where I can monitor lighting by the moment."

Image Modes. While the range of options vary from camera to camera, digital cameras offer specific modes (such as auto, shutter priority, aperture priority, manual, portrait, night portrait, etc.) that can be used to create better images. Check you camera's user guide for details.

Autofocus. Modern autofocus systems are remarkably fast and accurate. Using flash in the studio, you probably shoot at small enough apertures to compensate for slight lack of focus accuracy.

Burst Rate. This refers to how quickly a camera makes exposures. Some professional cameras can record three, five, eight and more shots in one second. Sequence shots can be quite effective for weddings.

To master any new camera, start with the instruction book for basic education. Numerous operational modes are accessed on a digital body

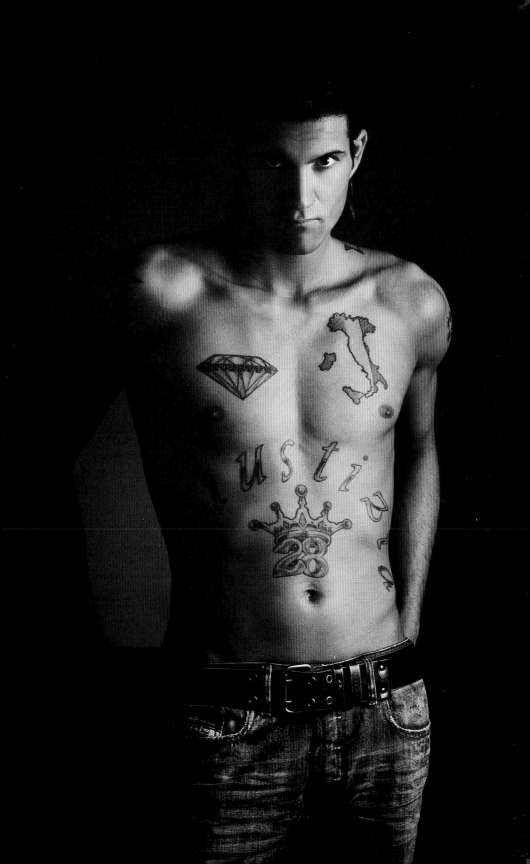

Anthony Cava isolated the young woman by lighting her from the side against a dark background. "Using one light source adds drama," he says.

by highlighting them in a menu on the rear LCD screen. Mastering a new digital camera may seem a bit frustrating, but once you become better acquainted with it, you'll realize its versatility.

◉ IMAGE SENSORS

In digital cameras, images are captured on tiny image sensors rather than on film. There are two types of image sensors on the market, both made of silicon, and both comprised of millions of tiny light sensors.

CCD. CCD (charge-coupled device) chips offer an excellent tonal range, are very light sensitive and produce less noise, the digital term for grain. This is the image sensor type used in most consumer-grade cameras. Captured data is moved from the chip to other on-board electronics and is then converted to digital values. For this reason, these chips are more costly to produce than the CMOS type.

CMOS. CMOS (complementary metal oxide semi-conductor) chips are used in most professional cameras and will eventually be used in consumer-grade models because they are less expensive to make (because the data processing takes place on the chip itself) and last longer. Using a camera with a CCD chip, you have to carefully control the lighting in

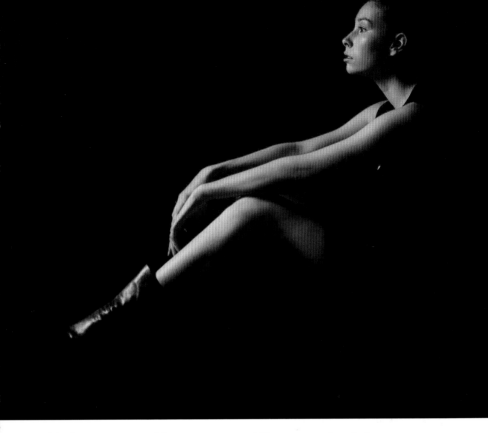

highlight areas to avoid overexposure. That precaution is less necessary with cameras that use CMOS chips.

Megapixels. Perhaps more important than the type of sensor your camera uses is its megapixel (MP) rating. The higher the rating, the greater the amount of image data captured, and the wider your options when it comes to making enlargements. Most consumer-level cameras have sensors that, as of this writing, offer approximately 3 to 5MP. Most digital SLRs offer sensors rated at 6–11MP; the former will be sufficient for printing an 11 x 14-inch image, while you can rely upon the latter to capture a photo you intend to print at 16 x 20 inches or larger. Medium-format digital backs capture still more data on higher-rated image sensors.

When Doug Jirsa shot this pleasing portrait, the man had opportunities to see his pictures at intervals on a nearby monitor tethered to the camera. He chose this and other poses after the sitting and took paper proofs home.

⊙ MEMORY CARDS

Once captured by the image sensor, digital images are stored in the camera on small memory cards that hold 56MB, 128MB, 156MB, 512MB, 1G, 2G, and more data (some microdrives can hold 8G of data). Memory cards should be chosen with the capacity you need for various sessions. When a card is filled, replacing it is faster than changing a roll of film. Photographers working on location carry several memory cards, enough for hundreds of pictures depending on the file size chosen. Wedding photography is particularly hectic, and using a 256MB or 512MB memory card allows you to take a lot of pictures without having to switch cards. In the studio where you can replace cards quickly, you

can choose any card capacity you want. Note that the more pictures a card holds, the more it costs.

The number of images that can be stored on a memory card depends on the card's capacity and the file size of the image (see below). Various memory card formats are available. Check your camera's instruction manual to determine the exact type that's needed for your camera.

○ RESOLUTION

Every digital image is made up of tiny dots called pixels. The term "resolution" expresses how close together the dots in an image are. In high-resolution images, these dots are close together. For instance, there may be 300 dots per inch (expressed as 300dpi). An image in which the dots are farther apart is considered a low-resolution image. Such images (say, those with 72dpi) do not offer us the quality of higher-resolution images. While high-resolution images may appear sharp, low-resolution

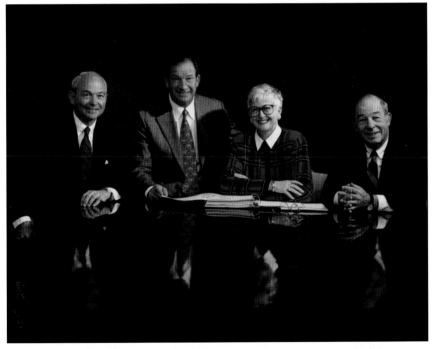

Board members of a foundation sat for their portrait at a table in David LaClaire's studio. He lit them to separate them from the background and give a look of importance.

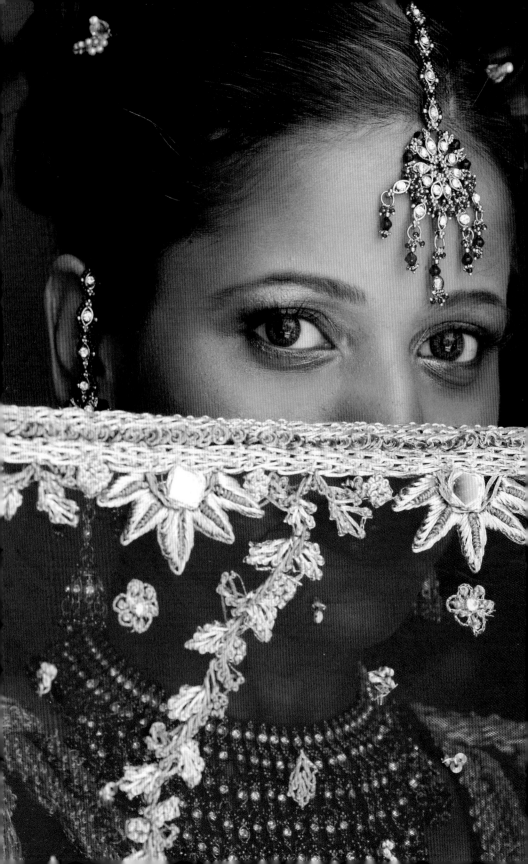

photos can appear grainy or blurry. 300dpi has become the standard resolution for prints meant for reproduction because you can't discern better quality than that from most printers.

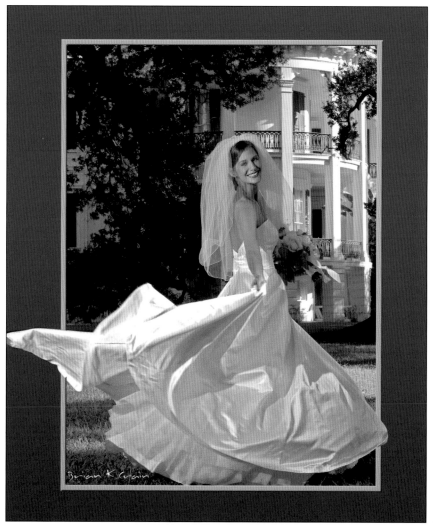

ABOVE—Brian Crain solved several photographic problems beautifully in this environmental portrait. He lighted the bride softly with electronic flash, placed her against a shady part of the mansion, and had someone off-camera at left hold her skirt. The tree in the left quarter was darkened in postproduction. FACING PAGE—Mystery and glamour are combined in this unusual bridal portrait by Dina Douglas. She shot by natural light at a large Indian wedding to make an image reflecting the bride's heritage.

The higher the resolution in an image, the larger the file size. As discussed previously, this limits the number of images that you can store on your memory card. On the plus side, it provides you with a finer image quality and more output options when it comes to making enlargements.

"Image quality," says Dave Montizambert in *Professional Digital Photography* (Amherst Media, 2002), "is no longer an issue for high-end digital capture. The quality that professionals demand has arrived. . . .

IMAGE SIZE AND RESOLUTION

This material was adapted from *Beginner's Guide to Adobe Photoshop* by Michelle Perkins (2nd ed., Amherst Media, 2004) with permission of the author.

What is the relationship between image size and image resolution? Keep two things in mind that apply whether you scan a photo, use a digital camera, or make an image from scratch in Photoshop. First decide what the final dimensions of the image need to be. Will it be a quarter page in a book or a 16 x 20-inch print? Second, determine what the final resolution of the image should be, such as 72dpi (dots per inch) or often 300dpi. Knowing the answers to these questions, you are ready to create the image.

Multiply the resolution by the dimensions of the image. Here's how:

Imagine you are making a print 5 inches high and 4 inches wide, and you want the resolution to be 300dpi. To make the proper size file, multiply 5 inches x 300dpi for height and 4 inches x 300dpi for width. The answer is, you need an image 1500 pixels tall and 1200 pixels wide. Later if you need to make an 8 x 10-inch print on an inkjet printer with a resolution of 700dpi, the original file won't work. You need a file 7000 pixels tall (10 inches x 700dpi) by 5600 pixels wide (8 inches x 700dpi). You will increase the image to a larger file.

After you settle on image and file sizes for prints, you won't be bothered making frequent calculations. Meanwhile, juggle file types and sizes, make prints, and become familiar with the possibilities.

The camera you choose will offer numerous options to help make the portraits you make as beautiful as possible.

In contrast to several earlier group pictures with dark backgrounds, this one by Doug Jirsa contrasts the family against white. The daughter, father, and son stood on boxes to frame the mother.

File size is, however, still a relevant issue. A majority of your work (perhaps 80 percent) will be reproduced in 8 x 10- and 11 x 14-inch prints, and a 6MP camera can produce image files that will make stunning 30 x 40-inch prints." Dave explains that inkjet and other printers are very sophisticated today and adds, "Clean, high-quality, RAW-captured files and printer software" make possible large format print sizes.

O FILE SIZE AND COMPRESSION

File Size. File size is the amount of disk memory needed to store and/or process an image. Larger file sizes require more storage space and take longer to be transmitted electronically. Comparing file sizes is roughly equivalent to comparing print sizes. The file size of your image is dependent on the image resolution and the compression format you select. Left at its default setting, your image file will be captured at the highest resolution your camera can support.

Creating a top-quality file is critical when shooting digital portraits. Images (above and facing page) by Tim Schooler.

JPEG Compression. File compression settings determine the file sizes of digital pictures, the number of images that your memory card will hold, the quality of any enlargements you will make, and the rate of speed at which they can be transmitted over the Internet. The finer the setting (the less compression), the less data is thrown away and the better the quality of larger prints such as 16 x 20 or 20 x 24 inches. At its default setting, the camera will choose a mid-level compression level.

Basic. This setting produces the highest level of compression, resulting in a smaller file size and lower image quality. Images with such a high compression level are acceptable for e-mails to clients or to post on a website.

Normal. This setting can be used to capture images for e-mail and website viewing. You may also be able to produce acceptable smaller prints (up to 5 x 7 inches).

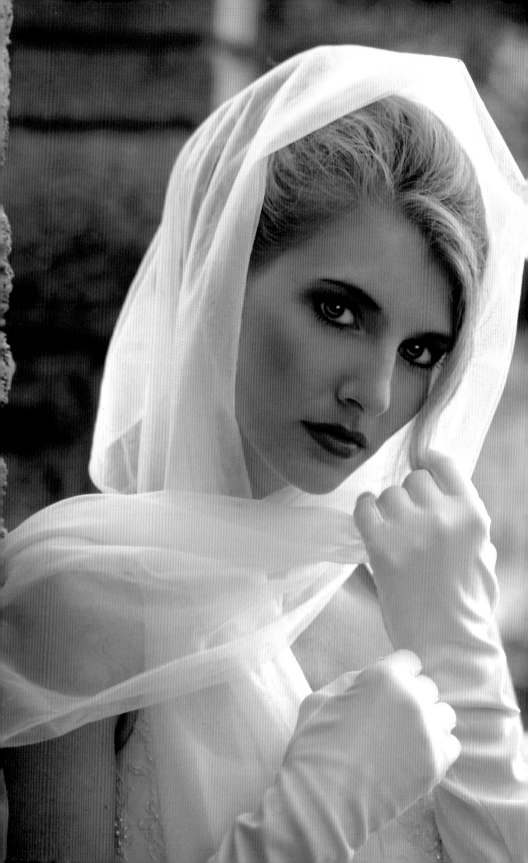

Rick Ferro is well known for his elegant wedding and engagement photography (above and facing page).

Fine. This setting offers the least image compression, resulting in images that can be enlarged to 30 x 40 inches if the exposure, color balance, color correction, saturation, contrast, and luminosity are correct. Again, at this setting, you will be able to capture and store fewer images on your memory card.

Also involved in the image quality is the megapixel rating of your camera. The higher the number, the finer the image will print.

Computer guru Dave Gatley says, "There's no average file size that fits all situations. So some professionals always shoot and store the maximum quality image. You can downsize from that if you need a smaller image/print. But you can't go from a lesser-quality image up in size to match the higher quality image you could have recorded first in the camera. Many professionals choose to shoot using the RAW setting [see page 59] for that reason."

Dave Gatley, continues, "When you compress an image to the level of basic you are throwing away huge amounts

of subtle but very important color information. Normal is doing the same thing, but less information is thrown away. Fine is still a compressed image, but the loss of information is arguably unnoticeable to the human eye. You are storing a better range of fidelity, contrast, color temperature, etc., than is available on certain film types."

Note: Don't confuse resolution with image quality. High resolution means the photograph contains a great deal of image data, but image quality also includes other factors, like color fidelity and tonality, which are so pictorially important.

TIFF Format. In addition to JPEG compression options, some cameras allow you to save images in the TIFF format. This format offers lossless compression, which means that no data is thrown away. For this reason, the resulting files are larger. Giving people images in JPEG will assure they can open them more easily.

RAW Format. Capturing an image in this format means that it is captured without any in-camera processing resulting in as much data as possible. Variations in image quality can later be adjusted in a computer program. RAW offers more manipulation options later and requires the most file space. To make any necessary corrections to these files, these large files must be converted either with manufacturer's software or a program like Photoshop.

Creating great digital files isn't just about resolution—factors like color fidelity are also critical. Image by Dina Douglas.

A UNIVERSAL RAW?
By David Arnold and Gail Rutman

Powerful as RAW is, it needs to go at least one more step to gain full strength: universality. Currently each camera manufacturer employs its own format, and none is compatible with the others. Even newer and older versions of what is supposedly the same RAW format aren't always compatible. This means the developers of Adobe Camera Raw, Bibble, Capture One, etc., have to painstakingly rework their software to accommodate an almost continuous stream of new formats, causing delays, and increasing costs to you, the consumer. It can also mean that down the line you may find that your new and "improved" RAW conversion program can no longer open your old images.

We have thirty-year-old slides that we're still scanning and selling. But thanks to the proprietary and ever-changing nature of RAW formats, there are already five-year-old RAW files that can no longer be fully processed by their manufacturer's latest RAW converters. As incompatible RAW formats proliferate, so will such problems.

To eliminate these problems, Adobe recently released their Digital Negative Specification, a royalty-free public format for RAW digital camera files, plus a free program that converts any proprietary RAW file to a DNG (Digital NeGative) file. DNG is the Rosetta Stone of the otherwise incompatible RAW jungle. It is, in Adobe's words, "a single format [that] can store information from a diverse range of cameras. The unified and publicly documented Digital Negative Specification ensures that digital photographs can be preserved in original form for future generations." At http://www.adobe.com/dng you can read more, and download the free DNG converter. For additional information read the articles at http://www.outbackphoto.com/artofraw/raw_17/essay.html and http://www.digitalmediadesigner.com/articles/viewarticle.jsp?id=28283.

As of yet no camera manufacturer has boarded the DNG express. One reason is that it was just announced. Another is that each manufacturer wants to keep its processes secret. Actually, the Digital Negative Specification allows this, since it provides an area where they can safely include their proprietary information. But whether or not Adobe's universal format benefits the manufacturers, it certainly benefits us, the customers.

What can you do to support DNG? (1) Go to http://www.photoshopuser.com/members and click on the "sign petition" link. (2) Start using the DNG converter to archive your images, thus assuring you'll still be able to access them years from now. (3) Until DNG is universally adopted, also archive a copy in the proprietary RAW format you've been using. Merely converting everything to TIFF or another common format is a poor alternative, since future developments will almost certainly give us the ability to pull more out of the RAW image files you shoot today.

David Arnold and Gail Rutman have been writing about photography and computers since 1980. Visit their website at http://www.arnoldrutman.com.

3. COMPUTER HARDWARE AND SOFTWARE

○ COMPUTERS

Platform. Either a Mac or a PC will serve you well if it's up to date enough. Owners of both types of computer may believe in the superiority of their systems, but the truth is, either can serve you well in a studio. Ideally you should have two computers, one to use for office duties

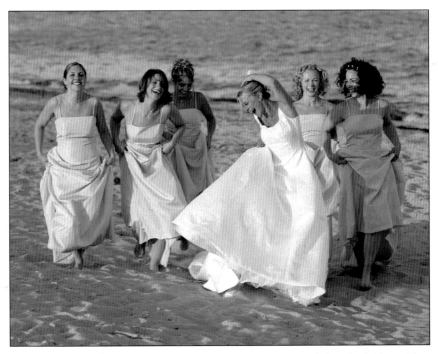

ABOVE—Tommy Colbert, a candid wedding specialist, suggested that the bride and her maids remove their shoes and enjoy the surf and sand while he caught them in a gleeful array. Afterwards he showed them how lovely they looked on his laptop. FACING PAGE—During a time exposure Brian Crain made of the newlyweds he fired an electronic flash behind them to separate the couple from the background. Only a few computer touches were added to increase the contrast.

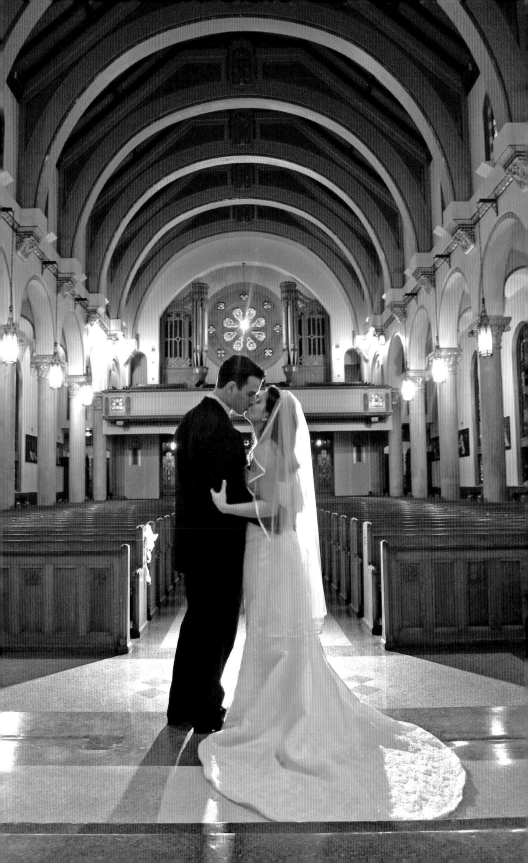

Deborah Ferro positioned this young girl against a dark background that added to the dignity of the portrait. The key softbox was at the left with a reflector at right, a simple and pleasing arrangement.

and the other to download your images onto and use "as a virtual darkroom" for image manipulations, color corrections, and to ready your images for output—whether you'll send your image files to a lab or print them yourself. You can get by with one computer, but your workflow may not be as efficient. Jeff Smith, author of *Professional Digital Portrait Photography* (Amherst Media, 2003), says "Remember, your profits will increase as your efficiency in producing images does, and with that money you will easily be able to pay for a second computer."

Though I get by with one computer, I agree that a second one could be handy if it were mainly devoted to working on pictures in programs

such as Photoshop. Consider using a laptop for slide show projection and for downloading images at a wedding or portrait location. Jeff Smith says when you spend money on "necessary equipment—and the education to use it," you'll eventually save time. Education in the form of personal instruction is a wise way to get a head start on using complex computer programs.

For another view I asked Dave Gatley, a computer expert, how he felt about using several computers, and he told me, "Actually, one fairly powerful desktop computer, if chosen properly, with the appropriate software, will cover almost all the needs of a small-to-medium-size studio. The photographer can add an additional computer as required to

Kurt Brewer talks with seniors to discover their ideas about how they want to look. Among the photographs he took of this handsome young man were close-ups for a "leading man" look.

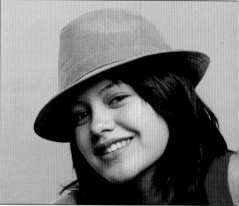

LEFT—This is a preview of a portrait shot for chapter 6. I lighted Dianne with a softbox in front, high enough to create a small nose shadow. The lighting and pose selected were simple, and she was delighted with the sitting. RIGHT—I positioned the umbrella at the right to brighten Patti's face and used a reflector at left. She brought the hat, and we agreed it would be a cool prop. Patti appears again in chapter 6.

handle more dedicated functions such as editing images. The first computer could be used by the office staff as business grows."

New Models. Computers become less expensive and more powerful every year. Even if your computer is only a few years old, it's possible you can buy a better, faster, and more versatile model to more quickly handle batches of images. If you plan to buy a new computer, start by reading store ads and manufacturers' catalogs and by searching the Internet. Consider carefully if you need the most powerful, expensive model. To help you decide, seek advice from a knowledgeable friend or a professional. If that's not feasible, settle on a budget, and find out how much speed and capacity you can get for your money. Displayed computers are usually accompanied by a list of their specifications. Prices are based mainly on the amount of RAM, hard drive capacity, and processing speed. Match what you need to what's available and affordable. First, however, if it's feasible, investigate having a computer built for you.

Custom-Made Computers. These may sound expensive, but they're not. There is a good range of non–brand-name PC models assembled by custom shops. They usually have a display of ready-made units, or they will build a CPU to order. My experience indicates you'll pay less this

way than you would for an equivalently powerful brand-name model. The shop where I bought my current PC assembles numerous different models, greater in speed and memory as they increase in price. Custom technicians use the latest hardware and can leave out features like games that you may not want and may install programs you want. My custom model cost a few hundred dollars less than buying a name-brand computer with the same specifications. When I need advice or an adjustment, my custom shop handles my request within a day or two. At an electronics store I might wait longer and be charged more.

Upgrading Your Existing Computer. Depending on the age and specifications of your computer, it's also feasible to have it upgraded at an electronics store or custom shop. More RAM can be added, and other updates can be made to enhance your ability to work with and store your

David LaClaire understands how to make people glow by using a large softbox and subtle fill light to emphasize their pleased expressions. A minimum amount of computer enhancement made later is invisible

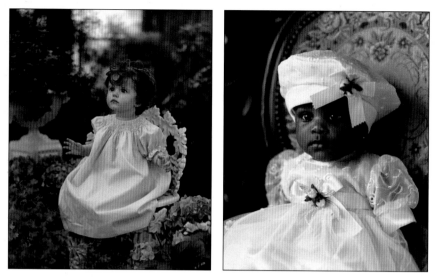

ABOVE—Behind the child at left is a painted, fantasy-type background. Laura Cantrell shot while her assistant distracted the child with a large doll. The baby in the brocade chair (right) also stared in wonderment, giving Laura an absorbed expression captured in one of her studio shooting areas with controlled window light. FACING PAGE— Wedding photojournalist Tommy Colbert finds locations for portraits by soft daylight. The red bouquet prop helps set this image of a bride apart from the ordinary.

digital images. The upgrading cost should be less than buying a new CPU. However, if your computer is three or four years old and is becoming temperamental, you'll be happier and more secure with a new model that runs faster and has more hard drive space. You might also consider adding an external hard drive to augment CPU storage. Ask a computer technician at a store or custom shop. Some such hard drives are very compact.

○ IMPORTANT CRITERIA

Whether you are looking into buying a new computer or have decided to buy a new one, there are a number of things to consider.

Processing Speed. Processing speed is measured in megahertz (MHz), such as 800MHz. Because processing speeds are calculated using various methods, it is possible that a 500MHz Mac G4 is faster than an 800MHz Pentium III PC. As of this writing, processing speeds

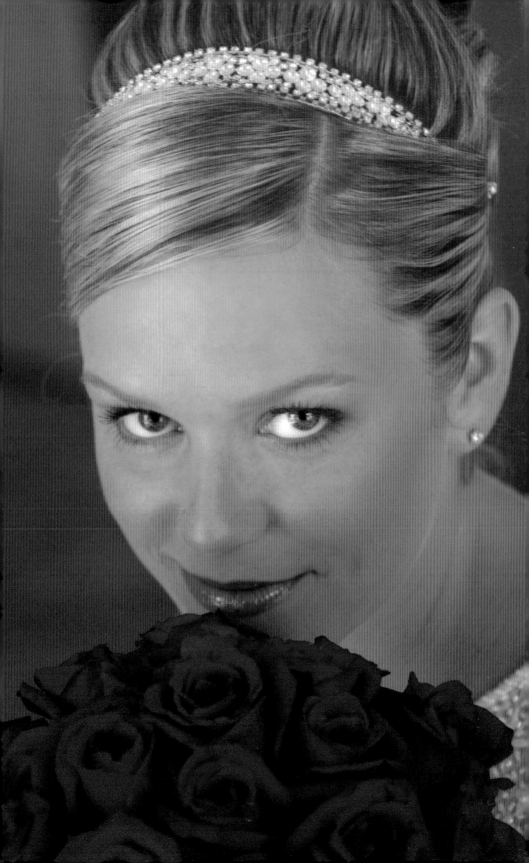

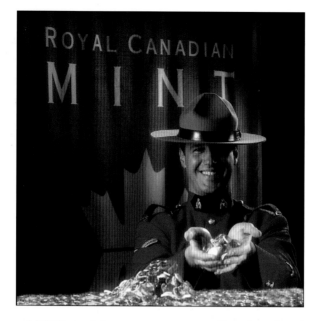

Anthony Cava created a simple set to photograph a Royal Canadian Mountie for a poster using one light on his face, a light on his hat for separation, another light on the coins, and one on the background.

of 2GHz and faster are common. Your best bet is to check the requirements of any software you plan to use and be sure that the computer you plan to use (or buy) has sufficient speed.

RAM. RAM, or random access memory, is where your programs are loaded from the hard drive. Running programs from RAM allows them to function without lag time. Having enough RAM in your computer is important to working smoothly with digital pictures, especially in image-enhancing programs. Having at least 512 megabytes (MB) of RAM improves operational speed. Photoshop CS uses more RAM than any previous versions, and a typical photograph takes about 50MB of RAM. Dave Gatley suggests that to simultaneously handle numerous software programs and to have room for images, "a minimum of 1GB of RAM is not overdoing it." Adding RAM to your computer gives you more storage space and power to access it.

ROM. ROM is read-only memory that stores instructions the computer uses when it boots, before the system software loads. Think of ROM as permanently stored information, whereas RAM is temporary memory (storage space) to be used as needed that can be erased and reused.

Hard Drive. The hard drive is a device on which data (files and/or folders containing images files, documents, and programs) is stored in your computer. The term "hard drive" is actually short for "hard disk drive." When you work with a program such as Adobe Photoshop or Microsoft Word, you need plenty of hard drive space (60 to 80GB or

Doug Jirsa stores a few choice sets in his studio. This one created a period atmosphere in the image. Proofs from the session were ready to take home before the child and her mother left the studio.

ABOVE—While shooting a wedding Dina Douglas found this setting outside the ladies' lounge at an inn. She asked the man to pose while she climbed a wall opposite for a perfect composition. The reflections add interest to the picture. FACING PAGE—Tim Schooler made this glamorous photo of a senior he felt had "star quality." He used one softbox at the right. In the series, they moved her hair into several positions, but this was the favorite.

more is ideal). Once you've captured your images, they can be downloaded to your hard drive and enhanced using an image-editing program. External hard drives can be added, providing you with additional storage space for your image files.

● MONITOR SELECTION

Since the beginning of the computer age, the standard monitor has been the CRT (Cathode Ray Tube) type. Now, it is being supplanted by LCD plasma monitors that are flat and thinner, so they take up much less space than CRTs.

Seventeen and 19-inch monitors (measured diagonally) are most common and least expensive in CRT models. The larger the monitor,

Brian Craine explains, "I took this at the bride's home before the ceremony. The flowers were so beautiful and the petals lead your eye to the bouquet she holds." Imagination pays off.

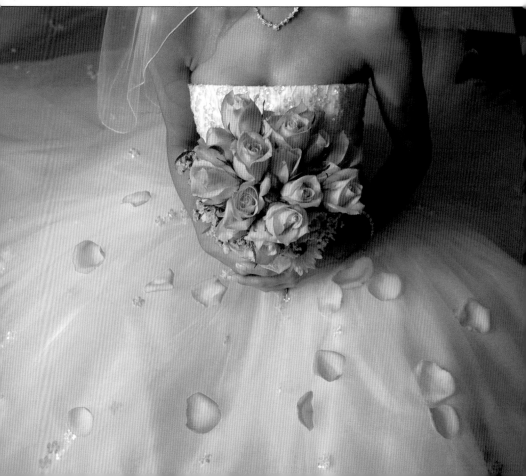

When you work at enhancing photographs, larger-size monitors can be a blessing. It's very helpful to be able to view the image at a large size so you can see all the details. Photograph by Anthony Cava.

the more easily you see graphics and photographs. When you work at enhancing photographs, larger-size monitors can be a blessing. I currently use a 19-inch CRT flat-screen monitor that's a few years old, and it's quite adequate for writing and imagery both. A flat screen gives you a minimum of reflections from desk lights or whatever is behind you.

An LCD plasma-screen monitor may be somewhat brighter than some CRT types and may seem easier to work on. Laptop computers all use LCD monitors, and since you have to be right in front of one to see its data clearly, people next to you on a plane, for instance, can't see what you are writing. In any case a thin, flat LCD monitor is a neat space saver.

Today's computer monitors should all give you very good color and contrast with a few adjustments. Some users have their monitors calibrat-

ed to correctly match what's sent to a printer. Calibrating meters are expensive, but a technician can do the work for you. If the color on your monitor seems distorted, get advice from the manufacturer on how to correct it.

Monitors cost more as their measurements increase. Some brand names are more expensive than others. Check monitor information on the Internet and ask questions when you buy because monitors last a long time.

O SOFTWARE

There is a wide variety of photo-friendly software titles on the market, including image-editing programs, monitor calibration programs, and more. While we won't cover them in detail here, note that selecting and using programs like Corel Painter and Adobe Photoshop or Adobe Photoshop Elements (and a wide variety of compatible plug-ins) can help you retouch, refine, and add special effects to your images. Amherst Media and other publishers offer a wide variety of books that will help you learn how to use these programs.

O STORAGE NEEDS

CD/DVD Burners. A CD/DVD burner is a device that allows you to record your files onto a disc for storage and/or backup.

CD-Rs. These compact discs can be written to only once but can be read repeatedly. Because of their archival stability, CD-R formats are preferred for recording images.

CD-RWs. These discs are rewritable. Their surfaces are more vulnerable than CD-Rs, and there's a risk when using these CDs that images may be accidentally erased.

DVDs. DVDs can hold much more data than CDs. These come in two types, DVD-Rs (which can be written to only once) and DVD-RWs (which are rewritable).

4. PRINTING OPTIONS

⦿ IN-HOUSE PRINTING

Leading companies that manufacture photo printers strive to offer an array of new and impressive models that turn out prints large and small. Printers priced at $100 or less can produce quite lovely portrait or landscapes images. For $200, $300, $400, and higher you get more versatile printers that produce superb quality and color fidelity, as good as you see from printing presses. How pricey and elaborate a printer you need depends on the volume of prints you anticipate making, your budget, and how many printing options you require. Excellent prints will promote your studio. Whether you wish to make both proofs and finished prints with your own printer is a personal and business decision that may depend on your production schedule, volume, and skills.

Examine your stored prints for signs of color shift.

Inkjet Printers. Epson, Kodak, HP and other companies now offer inkjet printers that use inks with archival qualities. Research and compare numerous printers on the market. Keep in mind that print archivalness is based on storage in ideal conditions (protected from heat, humidity, and ultraviolet light). Every few years, examine your stored prized prints for signs of color shift. Become familiar with printer manufacturers' websites to learn about new models and new inkjet configurations.

Fuji Pictography 3500. Doug Jirsa's portrait studio uses a Fuji Pictography 3500 printer. This and other high-end printers are unique in that they use silver-halide photographic paper, which absorbs pigments to produce images. Doug claims that Pictography prints are supe-

COLOR THEORY

The more you understand about color, the better able you will be to evaluate computer screen and printer images. You don't have to know a lot of technical stuff about inks in inkjet printers, but it helps to have a basic understanding of how colors combine to make our pictures look real or even modified. Color theory is a lot less confusing than it sounds.

Painter's Colors. If you have ever painted with watercolors, oils, or acrylics, you remember that red, yellow, and blue are the primary colors. That means all other colors are made by mixing two (or three) primary pigments, but basic red, yellow, and blue can't be mixed using other colors. Painters combine red and blue to make purple, known photographically as magenta. Blue and yellow make green, known photographically as cyan. Red and yellow make orange. On an artist's palette, besides the primary colors, dozens of other ready-mixed hues are available from tubes and jars to create portraits or scenes. Artists also use black, which is the absence of color and is impractical to mix. I enjoyed mixing pigments when I trained in painting before becoming involved in photography.

Photographer's Colors. Where painter's colors denote mixed pigments, photographer's colors are mixed colored light sources. The colored light emulates the electromagnetic spectrum seen in nature's rainbow, with ultraviolet at one end and infrared at the other. The primary colors of light are red, green, and blue. When combined, blue and green light (or printing ink) create cyan; red and blue make magenta; red and green create yellow. Check for yourself. Buy some inexpensive colored gels and hold them up to white light beamed to a white surface. At first you'll be amazed how a red and green gel make yellow. Lighting masters of the musical stage use such colored gels to create magic out of mixed light sources to augment glamour, drama, suspense, and décor.

Inkjet Printer Colors. Cyan (C), magenta (M), yellow (Y), and black (K) are basic inkjet colors, though newer more complex printers add additional colors. The first two combinations, $B+G=C$ and $R+B=M$ would make sense to a painter, but red and green create yellow because inks absorb other colors, so yellow is reproduced with ink that absorbs blue light. Combined inks absorb various hues in our printed images.

Printers work by using capsules of CMYK, plus more colors in some models, which combine in unimaginably small dots to represent the subjects we light and photograph.

Modern digital printers give us remarkably true images on paper and other surfaces. We can't actually watch printer colors combine, but we can see and adjust color on a computer monitor to suit our tastes, conventional or otherwise. To achieve color accuracy, computer monitors need to be calibrated using available programs (such as Monitor Easy Color 2) to make certain you get the colors of subjects. If the color in your prints is not satisfactory, look for a program to calibrate your monitor, or ask a friend to borrow his/hers. Keep in mind that color perception is both objective and subjective.

Experiment with computer graphics or color variations in your portraits to better understand how colors influence faces, clothing, backgrounds, and especially mood. For a deeper understanding of color theory, see *Professional Digital Photography* by Dave Montizambert (Amherst Media, 2002).

rior to even the finest inkjet prints, and the difference is that inkjet images are on top of the emulsion, not within it as with silver-halide prints. Fuji prints have a longevity rating of 50–100 years depending on the conditions in which they are archived. Doug says he enjoys being able to tell some clients that their portraits will probably outlast them.

If you work alone or with a small staff, your valuable time will be needed to take pictures and do other things to support your business. You'll need at least one digital printer, but a lab can save you time and maybe money when you don't have to add another employee. We'll take a closer look at this option in chapter 9.

○ PROFESSIONAL LABS

Many portrait photographers prefer using professional labs to produce their proofs and prints. When I asked for views from Brian King, an experienced studio photographer, he told me, "Outputting in-house is always an option, but ask yourself what your goal is if you want to be your own lab. Do you want to only do proofs and 8 x 10-inch prints? If you are outputting larger images, you will need to buy a larger printer that's more costly, and the color cartridges are a routine expense. How much money do you want to spend on equipment? You should approach these options with your eyes wide open—and possibly your checkbook too."

The bulk of many studios' work is printed by a lab, but Brian says his studio also uses two printers. One is for proofing when they need client approval in a hurry before the order goes to the lab, and for executive rush glossies. The other printer is for 12 x 18-inch and smaller images. "However," Brian adds, "if an order has prints larger than we do in-house, as well as smaller ones, everything goes to the lab so all the prints match.

"I know Epson makes inkjet printers in sizes up to wall portraits, and I know of studios that do everything in-house, so it's feasible. I can't guess what's right for other studios. I just know that I want to concentrate on photography, and not be in the lab business."

5. LOCATING AND OUTFITTING A STUDIO

○ LOCATION

Where your studio is located is important, probably more so when your competition has a prominent spot on a main street. Here are some locations to consider:

On a Busy Street. It's not necessary to be located on a commercial street where people walk by, but if you're in the market for a new studio location, this option can prove profitable. Where there is frequent pedestrian activity a studio will get more attention. People will see your work on display in front windows, which can make an impression when they need portrait or wedding photography. If convenient street parking isn't handy, provide space for a few cars. To accommodate clients without cars, nearby public transportation service should be handy.

On a Side Street. If you advertise and promote your studio properly, it should thrive even if it's not on a busy street. An attractive storefront or nicely painted and landscaped remodeled home will be appealing. In advertising, include a photograph of your studio. Parking should be easier on a side street.

In a Mall. Your success or failure in a mall may depend on the shops in the mall. An adjacent grocery store could attract a diversity of people. Before paying rent in a mall, do some market research by counting and observing the people there. I've seen pleasant studios tucked into malls that prospered, and others that didn't, mainly because some people, especially mothers and children, would not be comfortable in that vicinity. Check mall rules and hours. Some leases might require you to stay open longer than you care to.

In Suburbia. If your client base has access to transportation, chances are good they won't mind driving a few miles out of town to a studio in

Robert Arnold immortalized a San Francisco street photographer after they agreed to exchange portraits. Joe Fox took Robert's picture with an old Graflex and then visited Robert's studio to stand for his own portrait. Daylight coming through a window was the only illumination.

a large home or building with attractive surroundings. Outdoor photo backgrounds in this type of setting could be close and comfortable. Teens could meet friends there and socialize while waiting for appointments. Suburbia can be a neat choice for a studio when it offers open spaces and perhaps room enough to add on to an existing structure.

LOCATION IDEAS

In a book titled *Photographers and Their Studios,* by Helen T. Boursier (Amherst Media, 2001), studios described and pictured include this variety:

- A studio in a seaside village frequented by tourists in the summer.
- A studio in a medium-size former office building with a converted interior and tall windows in a busy suburb of a large city.
- A studio in a converted home in a commercially zoned location.
- A studio in a large, renovated garage attached to a home and surrounded by a nice yard and great natural backgrounds.
- A former store converted into a studio with a camera-room window, outside of which is a white-wall reflector. On both sunny and shady days light coming through the window will help create a grand studio atmosphere where the photographer can also use flash to suit his style.
- A studio in a renovated barn with a new floor and walls. Partitions can be used to divide the space into convenient work and storage areas.
- One photographer took advantage of an existing large skylight that brightened a former fabric shop he converted to a studio.

You get the idea. Appealing portrait studios may be created in many places and can be designed to attract and charm visiting clients.

Having a studio in a spot that people will notice easily is a real asset, but it's not essential to be on Main Street if you can start around the corner. People will find your studio, and business will prosper because of how well you advertise and promote yourself. Once you have clients, word of mouth can be the most persuasive way to increase your business.

So find an empty store or rent a place with room to shoot, do computer work, and perhaps create a separate business office. Based on your budget, buy furnishings new or secondhand for the office, reception area, and studio. To make simple sets, I've found quite adequate chairs, tables, and other items at the Salvation Army and similar outlet stores.

Even if you have just inherited a small fortune, don't go to the trouble of building a studio unless you expect, or already have, an affluent

clientele. Remodel, be charming and successful, and then hire an avant-garde architect to help put you more prominently on the map. Whether you build or remodel, people may come to see your studio because they are curious when you announce you're there. If they make an appointment for a sitting, and your setup is modest, don't fret; remember, lots of successful photographers started small and moved to grander studios. Some shooters completely remodel a home or a building to start; others wait until their business begins to prosper.

Because there comes a stage in many professional photographers' careers when expanding the studio is a necessity, be sure to start a separate fund to make that possible. That fund could also be dedicated to replacing cameras, computers, props, etc., that a new or expanded stu-

Tim Schooler photographed this young lady on the porch of a building where the daylight was just right. He says, "I try to let subjects flow naturally, and she was comfortable here."

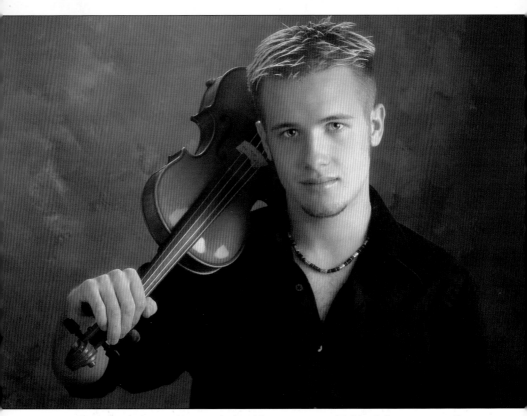

Frank Frost chose a front angle for this young man with his violin as a prop. He says, "I find there are very few rules about posing. We create poses and work with what we are given, which in this case was ideal."

dio may need. The photographers I know who work in impressively designed and furnished studios earned their settings as resourceful and successful shooters.

● STUDIO LAYOUT

How you lay out work spaces depends on your needs and your sense of design and décor. Remember the designer's mantra, "form follows function." Practicality counts when money is limited, but with plenty of money you can make the studio more beautiful and/or luxurious.

The work space in a photographer's studio can be designed in many ways depending on the shape and size of the space and the owner's needs and taste. Here are three variations.

Small Studio. Typically a small studio would have a reception area in front where the walls are enhanced with enlarged portraits and perhaps wedding pictures. (Actually, all studios should show the photographer's work.) Beyond the reception room could be the camera room, planned for photographic efficiency and the comfort of clients, with an adjacent dressing room (optional) and rest room. Next to the shooting space could be a room where pictures are downloaded into a computer, enhanced, and proof prints are made. If you plan to show pictures via a slide show, a viewing area will be required. Other postproduction space could be provided to sell and take orders. Also, a room for storage is

Frank and Cheri Frost's studio has two levels, and this is the reception area near the first-floor entrance. The receptionist's office is behind the door at left and adjacent (not seen) is a kids' section with crayons and toys. In this room customers wait for their sittings. Books, albums, and Frank's award-winning photographs are decorations. At right is an area they call the concession stand with popcorn, ice cream, and cold drinks. Off to the right you walk past vintage video games and enter the theater (not seen) with its eight seats and a curtained screen for portrait slide shows. The Frost studio makes people feel at home.

Upstairs at the Frost studio is the "wedding room" where Frank meets brides, grooms, and their families to show albums and discuss his wedding photography. Also in the room is a hutch full of albums, and adjacent are a frame room, Frank's office, a kitchen, and a rest room. The Frosts' comfortable surroundings please their clients.

essential. A small studio may be 1000 square feet with perhaps a separate area for children's photography. A lot depends on the configuration of the building, your imagination, and your budget.

Medium-Size Studio. Expand on the above basic plan to decide what the additional space of a medium-size studio will offer. The reception room could be larger with additional wall displays. Plan more room for production, orders, etc. A second camera room would be useful with its own backgrounds, or the space could be used as a children's play area. You could enjoy a larger main camera room with perhaps a window for natural light effects. A separate computer room with larger work tables to organize pictures would be nice. Presentation of digital slide shows could be done in a comfortable setting with additional furniture. These features could be arranged within a 1500–1800 square-foot studio, where imagination can devise facilities I haven't mentioned.

Larger Studios. More luxurious photographers' studios are illustrated in Helen T. Boursier's book, *Photographers and Their Studios.* Some of the best include sofas, flowers, a TV to entertain people waiting, and a fireplace. The owner's office might be as plush as one for an executive in a skyscraper, with paneled walls and tall bookcases. Work spaces would be larger and more elaborate, and separate rest rooms and dressing rooms could be provided. Several camera rooms would handle simultaneous sittings. A meeting room might be made available to the community at no charge, as a public service to enhance the studio's reputation.

If some of the above sounds like fantasy now, start to conceptualize luxury in your future to reward your success.

THE CAMERA ROOM

I once wondered about the term "camera room" and suspected it was where photographers stored their equipment. Then I discovered why it received its name—because it's where you shoot pictures as distinguished from the rest of a studio setup. The camera room is a center of creativity that should be large enough to work comfortably. Design it wide enough to arrange groups, and buy or build atmospheric sets that fit the space if they suit your business.

The camera room ceiling might be high enough to accommodate high backgrounds and tall light stands. Some photographers suspend softboxes from the ceiling, each large enough to hold two or more flash units. If you rent or buy a space with ceilings that are too high, consider having lower ceiling panels added—they could be ideal for reflecting light. With a lower ceiling, the room would also retain heat better in cold weather. A spacious camera room offers added photographic flexibility and can be impressive to clients.

The walls of the camera room could be off-white or a warm pastel color to reflect light and enhance skin tones. One or more windows that offer good north light can be an asset. Daylight augmented by flash in a softbox is elegant. Consider having closets fitted along a camera room wall for equipment and prop storage. Whatever its size, the camera room is the heart of a studio. It can inspire you and relax clients.

○ LIGHTING NEEDS

Studio Flash. The many brands and types of professional flash equipment can be stimulating—or confusing—especially when you're looking at a bunch of magazine ads. To determine which equipment will best suit your needs, familiarize yourself with equipment details on company websites, then call for literature, visit dealers, go to trade shows, and do whatever is necessary to make wise choices. Other photographers are a good source of information. Find out how they like the brands of flash they use. To compare features of several units, here are a few guidelines:

- Studio electronic flash is rated in watt-seconds (WS). The higher the WS number, the more powerful the flash unit.
- Basic studio needs for portraiture might be one 200WS and two 400WS units with an optional 800WS unit. Keep in mind that light

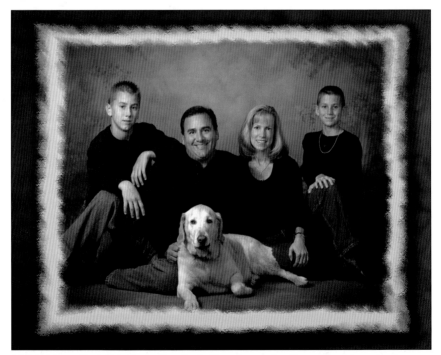

Lighted from the left in Doug Jirsa's studio, a happy family and a curious dog became a delightful photographic arrangement.

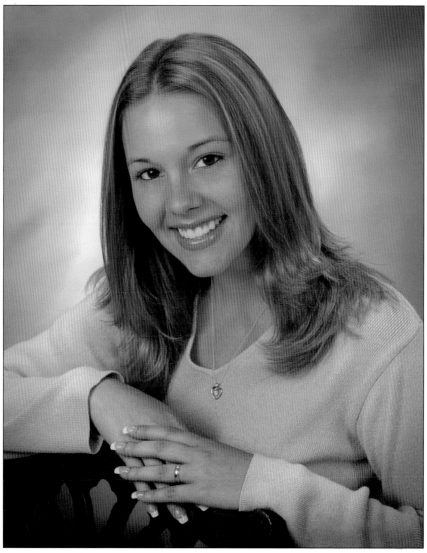

This was taken in Doug Jirsa's white-walled studio with a background light behind the young lady's head and a rectangular softbox in front with two flash units in it. She posed gracefully with her hands on the back of a chair.

intensity is flexible when flash power is dimmed 50 percent or 25 percent.

- Softboxes, umbrellas, and reflectors cut light intensity approximately in half and can be used to soften light for more attractive portraits.

LEFT—These ladies posed in Doug Jirsa's black-walled studio with a main light in front and a back light placed to highlight their hair. RIGHT—Window light can be used to create very flattering portraits. Photograph by Brian King.

Flash looks very bright even when half of it is absorbed by a softbox. To see the difference, aim a light at full power without diffusion directly at the subject and take test pictures. That's hard light compared to soft light from a softbox, with which you should also take comparative test shots (there's more about this in the next chapter). It's good practice to place lights 5 feet or more from subjects for better light control and subject comfort. Two or three flash units offer enough versatility for most portraits and groups.

Hot Lights. Hot lights (also called floodlights) are often 600W quartz types. Using them is an excellent way to learn lighting techniques because you see what the light does to faces in the way of highlights and

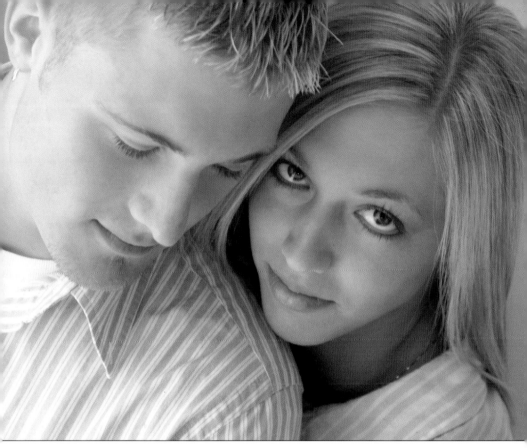

shadows more clearly than when using modeling lights built into electronic flash units. You can learn a lot using hot lights for still-life subjects. In a digital camera, the white balance can be easily adjusted to match hot light color temperature, which is 3200K.

The disadvantages of hot lights for portraits are that their heat can be uncomfortable and their use requires relatively slow shutter speeds, which can result in subject movement. Softboxes are vulnerable to heat from hot lights, and that's another disadvantage. However, special heat-resistant softboxes for hot lights are made by Photoflex. (See Resources.)

Window Light. In various pictures in this book you see the lovely results photographers achieve by using daylight as their main light. Often the source is a north-facing studio window as large as a double sliding patio door. When possible, an outdoor off-white wall may be placed a dozen feet from the window to increase the intensity of reflected sunlight or light coming through clouds. Not only is soft daylight

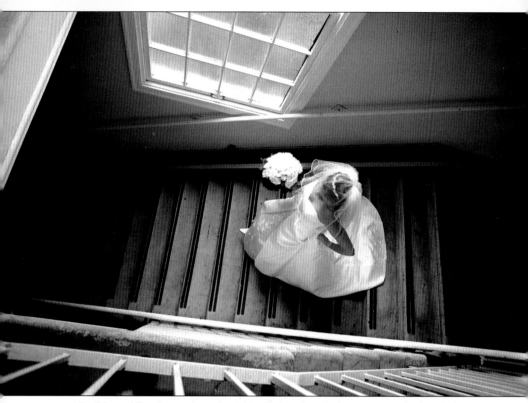

In this wedding image from David LaClaire, the window serves as both a light source and background.

beautiful for portraits, but it's easy to set your digital ISO speed to 200 or even 400 when clouds are present if necessary.

Use a large reflector on a stand to illuminate shadow areas of a face if needed, or have an assistant hold a sheet of 30 x 40-inch white illustration board for the same purpose. The closer you get the subject to a window, the darker the background will become because it's more underexposed. Use plain backgrounds, but don't light them for more striking effects.

On location when I've been lucky enough to find a patio where several walls of a home reflect light into a shady spot, I've achieved glorious, almost shadowless portraits. You can improvise that lighting in the studio with two white reflectors, one behind or at a 45-degree angle, and the other at the subject's side. Keep in mind that the larger the window in your studio, the more beautifully light spreads for groups.

○ BACKGROUNDS

There are numerous types of backgrounds for portraits. The easiest do-it-yourself kind is fabric that's wide enough (8 to 10 feet). A primitive way would be to fasten it to a wall with tape (but we'll get to a more sophisticated method shortly). If necessary, tape the bottom to the floor to smooth out wrinkles. Plain colors—light and dark, warm and cool—and perhaps soft patterns could be in your fabric inventory.

Seamless paper 8- to 10-feet wide is a popular professional photographic background. It's available in rolls and in a variety of colors at camera shops and from other suppliers. Light blue, pale yellow, red, and

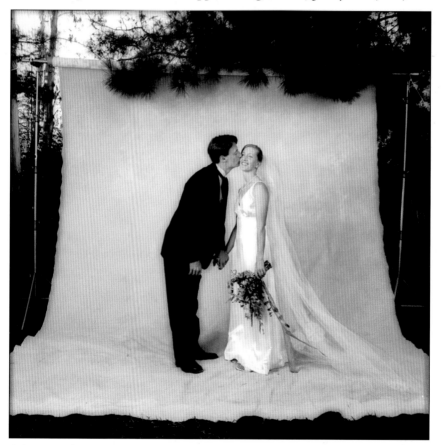

Robert Arnold set up a background on light stands and, starting with the bride and groom, photographed an entire wedding party in bright shade, individually and in groups. "I had lots of spectators enjoying the show," he says.

ABOVE—For a dramatic look, Anthony Cava arranged this group in black against a black background. He used a large softbox for their faces and backlighted their hair for separation. Imagine how their faces glow in a large print in their family living room. FACING PAGE—About posing, Kurt Brewer says, "I find it very effective to trade places with the subject, put them in my place by the camera, and demonstrate poses I'm going for. After the client sees a middle-age, balding photographer 'looking good' in various poses, they almost always relax and give what I ask for with very little coaxing."

dark blue are among my favorite portrait backgrounds. Seamless paper can be taped to a wall and dropped to the floor. Roll it under a standing model and you create a background without a horizon line. Afterwards, cut off soiled paper.

To suspend rolls of seamless paper, you can extend sturdy light stands and attach U-shaped brackets that will hold a bar that holds the roll of paper. For a more permanent result, you can attach metal or wood hardware to a ceiling or wall from which to hang seamless rolls on bars. Check photographic suppliers locally and on the Internet to find the required hardware.

To hold paper, fabric, or other materials, you can also consider constructing an 8-foot-wide (or wider) plywood frame support or a "wall" mounted on a base made of 2 x 4s. Add casters to reposition back-

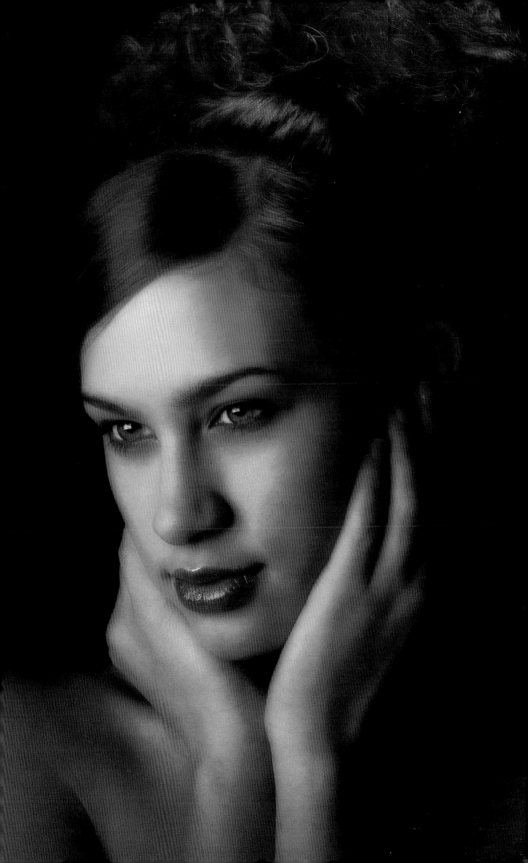

LASTING IMPRESSIONS

Doug Jirsa and his wife Donna have operated a flourishing portrait business for over twenty years on a main street in downtown Redlands, California. Their studio, called Lasting Impressions, is friendly, efficient, and successful, because Doug is an excellent photographer with well-honed instincts about pleasing teens and grownups, some who bring children. I had an interesting visit I want to share.

In the heart of Doug and Donna's studio are two camera rooms that face each other. One is high key with a white background and walls, and the camera room just opposite is a low-key area with black background and walls. Each room is about 15 x 25 feet. The main flash in each room is mounted in a high softbox facing the background. On each side of the background, lights with barn doors are suspended from the ceiling. In the low-key studio, lights on stands are ready as main or fill light. Alternate backgrounds can be pulled down and around the walls on a track in either studio. Doug's 645 Contax with a MegaVision S3 Pro digital back is on a sturdy stand that rolls from one camera room to the other. The walls of both camera rooms are delightfully lined with stored props such as alphabet letters, baskets, and fluted columns on which seniors like to lean. Also stored are antiques for atmospheric portraits and special sets for children.

grounds easily. A similar rack is illustrated in my book, *Studio Lighting* (Amherst Media, 2004).

A variety of commercial backgrounds (plus sets and props) are available from various companies (see Resources). I'm most familiar with Denny Manufacturing Company, Inc. The company offers a catalog that illustrates countless background types, patterns, and colors, plus props and portable sets such as a garden. Many of Denny's backgrounds are painted to order, usually on muslin. There are color patterns and scenes to suit every taste.

It is also feasible to buy lightweight canvas and paint your own custom backgrounds, plain or patterned. Consider spraying a series of adjoining soft-colored areas, brushing streaks that blend with subtlety, or mixing custom colors to give your portraits individuality.

○ PROPS

Furniture. With enough space in a camera room you can outfit it with chairs, tables, and whatever furniture you choose to make it look homey or businesslike. I prefer to use upholstered chairs, rather than simpler

A pleasantly formal pose and a harmonious background are combined in Bill Abey's photograph of two seniors in the Denny Manufacturing Company, Inc. studio. A large softbox at left was the main light, with another softbox at right.

chairs, as props, since the former are usually not seen in pictures. With the upholstered variety, people are comfortable, and the right shapes and colors can be a welcome touch when they harmonize with clothing.

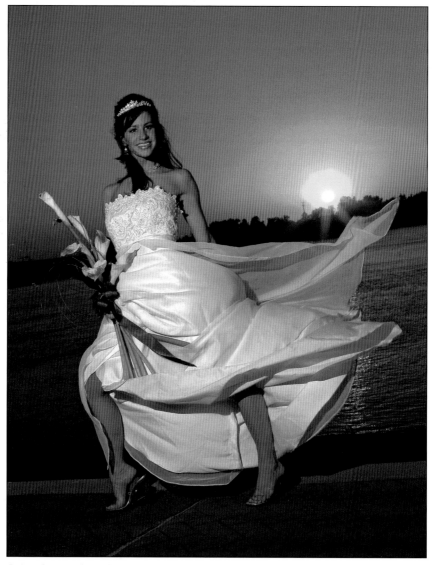

Brian Crain takes pleasure in photographing fashionable weddings in a journalistic style. For this charming image, Brian directed the bride to pose and shot a series of images as she changed positions. His flash was high on the left, and they continued until the sun disappeared.

Tim Schooler made this beautiful close-up portrait in his studio using a softbox and a reflector for the soft lighting on her face. He likes natural light and emulated it here.

Playthings. Areas of a studio outfitted with toys, child-size furniture, beach props, balls, and other items are popular with moms and children. The latter feel at home and can be directed to stop playing and pose just before the flash pops. As your portrait business grows and takes specific directions, your choice of props and backgrounds will help accent your individuality. Adults, high-school seniors, and mothers with children will come back to a studio where they were comfortable and/or amused while being photographed.

○ STUDIO OPERATIONS

Doug Jirsa's business is approximately 50 percent seniors, with the remainder divided between families, children, and adults. His clients'

ABOVE—Doug Jirsa has a large senior following. He encourages teens to choose their own clothes and props for cool pictures like this one. FACING PAGE—Fashion-inspired portraits are a hit with the young women at Tim Schooler's studio.

appointments are scheduled in half-hour increments, and latecomers must reschedule. His camera is digitally connected to an adjacent 19-inch monitor using a proprietary program from MegaVision that instantly shows what's been shot. Images can be enlarged individually or in groups.

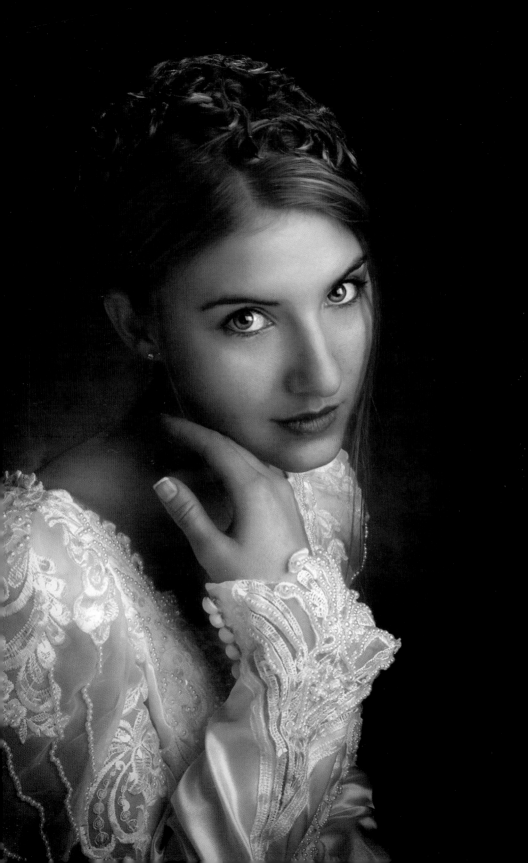

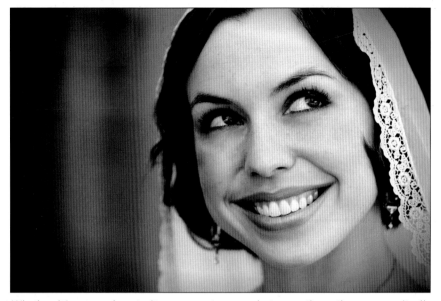

Whether it's a posed portrait or a spontaneous shot, sometimes the eyes say it all. Facing page image by Kurt Brewer. Above image by Dina Douglas.

"After a session is about six minutes old," Doug says, "we go to the computer and I talk with the subject about poses, clothes, hair, expressions, etc." Preferred pictures are saved, and those rejected are deleted. As the session continues, subjects may change clothes once or twice, and new props may be introduced.

At the end of a session, clients can select their favorite portraits. These are sent to the studio's main computer and, as the subject leaves the camera room, Quick Proofs are generated by a Xerox Phaser network printer onto 8.5 x 11-inch cardstock. This printout includes the studio's logo, copyright, and a brief statement about the transient quality of the proofs. The customer takes these home to consider and, if they can't make up their minds, they may come back to see their pictures enlarged on a monitor. For a basic price, seniors can choose five, ten, or fifteen poses, families may keep ten poses, and Doug always adds a few more. Customers make decisions according to their budgets, and there's no hard salesmanship. Before photographs are printed, Donna does whatever Photoshop improvements are needed.

Doug Jirsa is a perfectionist when it comes to making prints. Final images are done on his Fuji Pictography 3500 printer on silver-halide photographic paper. "Inkjet printers," Doug believes, "make excellent prints, but they will not rival a true continuous-tone photographic image." The Fuji Pictography printer cost about $3500 in 2005. Prints up to 8 x 10 inches are made in the studio, and larger ones go to a lab.

Pay yourself a salary from the beginning.

The studio sells several different packages priced for customers in various income categories. Their satisfied clients tell their friends about Doug, and that's the way a majority of the studio's new business originates. Here are some of Doug Jirsa's philosophies:

- Studios fail because the operators are good photographers and lousy businesspeople, or vice versa. To make a business successful you need to be both. That's one reason many couples run successful studios.
- Learn by working in another's studio until you have the confidence to start your own.
- Pay yourself a salary from the beginning.
- Some photographers prefer to have photo proofs made in a few days by a lab. We find that putting Quick Proofs in people's hands before they leave the studio gives them something tangible to consider and show friends.
- After a few weeks of shooting digitally, very few portrait photographers refer to histograms. They rely on experience and intuition.
- Pictures made with a handheld camera can be excellent if you compose carefully. However, using a tripod or studio stand can give the professional photographer's work more positive consistency.

6. PORTRAITS

○ PORTRAIT TRADITION

Before the advent of photography, portrait painters were an esteemed group hired to paint royalty, presidents, heiresses, captains of industry, and other persons of distinction. Almost as soon as photography was invented, military figures, political leaders, and average people were sitting—and holding still for long seconds—for daguerreotypes. In the nineteenth century, portrait studios made pictures by daylight, and since

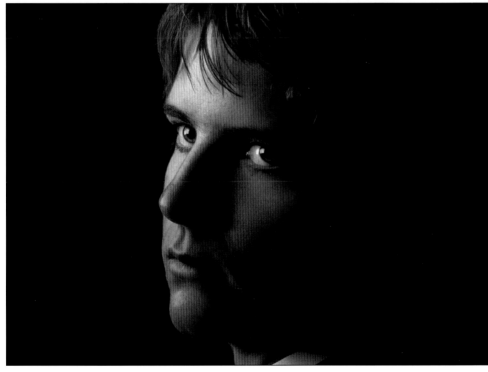

Kurt Brewer used one-sided light to add drama to this teen's face. He used a softbox and allowed the young man's head to neatly merge with the background.

LEFT—Portraits by David LaClaire invariably show meticulous posing and lighting, indicating that sessions were not hurried. A few decades ago, David learned dye transfer printing to please affluent clients before the digital era. RIGHT—It helps when lighting two people to place one behind the other and set the main light about the same distance from each. Brian King photographed these two friends laughing, documenting their happiness.

studios graduated to hot lights and electronic flash, the portrait profession has flourished.

In thousands of communities, photographic studios illustrate the population. That's a fancy way to say that farmers, senior citizens, mothers with and without their children, debutantes, salesmen, celebrities, and everyone who wishes to be immortalized for now and later is pho-

tographed in a studio by men and women who follow portrait traditions. You are part of a distinguished portrait tradition.

○ CREATIVE VISION

With digital capture, you pose, light, and photograph according to your personal vision, which combines your sense of design, your feelings about how facial forms and planes look appealing, and also how a subject's personality is revealed—just as you did with film. "Looking good" is really quite relative; we try to show character in people's faces as well as their beauty. A friend added this advice: "We have to photograph in harmony with the client's expectations." I asked my friend how you find this out—how you learn what the client really wants or expects. He said

almost everyone wants the attractive look of a favorite movie star or TV personality. Men may want to look like Rob Lowe and their wives might favor resembling Michelle Pfeiffer. Ask a subject if he/she has a favorite individual in mind, and you may be surprised, but don't promise mira-

Contrasting poses and lighting gave variety to these portraits of Patti. Her smile sparkles in each picture, lighted from separate sides. Young faces offer pleasant pictorial opportunities.

Pictures of Dianne against a red background were taken in quick succession without changing the lighting. She had not been formally photographed for a while, and we talked and joked to help her relax. When she changed her blouse, I changed the background for variety. We examined the pictures together, and she was satisfied that having a good time in a portrait session had paid off.

One of many portraits by Brian Crain in this book, this illustrates subtle lighting, an artistic blend of the model, the background, and a graceful, unusual pose. Brian says that by utilizing a fashion approach with his bridal shoots, he satisfies his creative side.

cles. There's no way we can light some portrait clients to look like celebrities. But we can choose lighting that flatters or glamorizes. We can't change facial structure but we can accentuate the positive.

○ PHOTOGENIC FACES

I enjoy lighting people, though it's sometimes tricky. Occasionally we have the pleasure of photographing a man, woman, or child whose face not only photographs pleasantly, gracefully, handsomely, or beautifully, but whose personality is cheerful. Their photogenic smiles make engaging portraits. Some people are naturally photogenic, though some don't know or admit it. Some benefit from plastic surgery. Movie and TV stars and professional models, especially women, can be photographed from almost any angle and look gorgeous. But lighting them effectively still takes expertise. Being very photogenic isn't always required of men, who seem to have "character" when their faces are somewhat rugged.

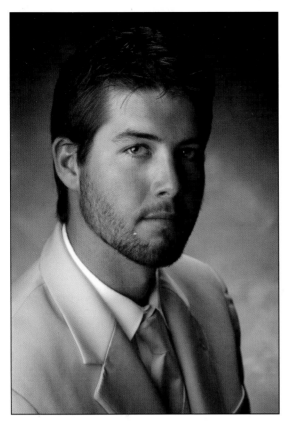

Kurt Brewer used what he called theatrical lighting for this teen photograph, which is appealing and dignified. Like the lighting of Brian Crain's lady in red (see previous page), this is also very smooth. A talent for lighting enhances the reputation of your digital studio.

Everyone doesn't have to be photogenic. Some faces are uneven with features too small or too large and not designed or arranged to please photographers. Then what?

Rejoice in Control. Place a softbox as key light with the subject's face turned directly into it, eyes to the camera. Add a fill light or reflectors and a background light if you wish. Pose and light the non-photogenic face as simply as possible. Accentuate the positive—eyes, jaw, mouth—whatever sings out. Take care with noses—they make shadows you don't need and, in some cases, they can make a portrait more difficult to light (and look at). Faced with a nose that needs rhinoplasty, treat shadows with a softbox and umbrella lights modulated by reflectors if necessary. Avoid shadows that draw attention to the area.

If lighting seems to make a face look a bit awkward, shift the lights. Ask the person to turn his/her head in each direction in small incre-

ments. Study the shadows that don't seem to go away. Ask the subject to lift his/her chin, which is an almost magical way to control nose shadows and the appearance of the nose itself, too. Faces shouldn't be tilted so high that the subject looks haughty but just enough to help normalize the features.

One-Sided Light. Some faces benefit with one-sided light, my term for placing the main light on one side, usually with a reflector or fill light on the other side. Highlights two or three times brighter than shadows (2:1 or 3:1 ratios) can improve some portraits.

These lighting methods work beautifully with photogenic people, and they may be used to hide half of a non-photogenic face. Those who need it can enjoy a somewhat mysterious appearance. If one-sided light seems too harsh, try to brighten the shadow side of the subject's face with

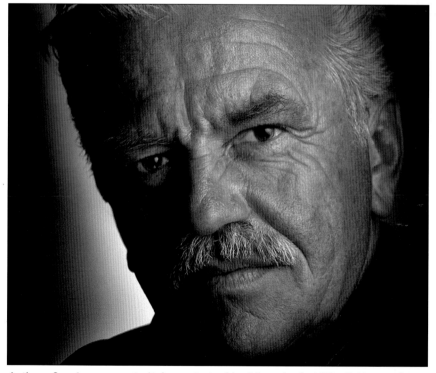

Anthony Cava's warm portrait demonstrates his philosophy that "the lights you choose and how you place them all serve to help you interpret a particular face." Cava says, "I'm always trying for a fresh approach, which means challenging myself often."

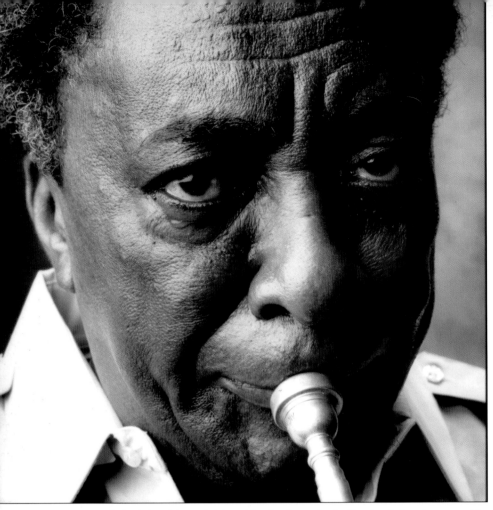

ABOVE—Robert Arnold was intrigued by the face of a janitor he met and arranged to photograph him as Jazzman with a trumpet. The image was used in an ad by a company that makes an eye solution. FACING PAGE—This young lady chose to wear a sleeveless top behind which Kurt Brewer projected a red grid for a change of pace in the session. Like most good portrait photographers, Kurt tries to keep the lighting simple.

another light or reflector. Maintain the mood without revealing too much of the face.

Oddly enough, some irregular-faced people have good profiles. Remember to light and observe and photograph profiles, because you and the subject may luck out.

Face Tilts. One of the first things good photographers do when they are presented with a face that doesn't seem to photograph well is to ask

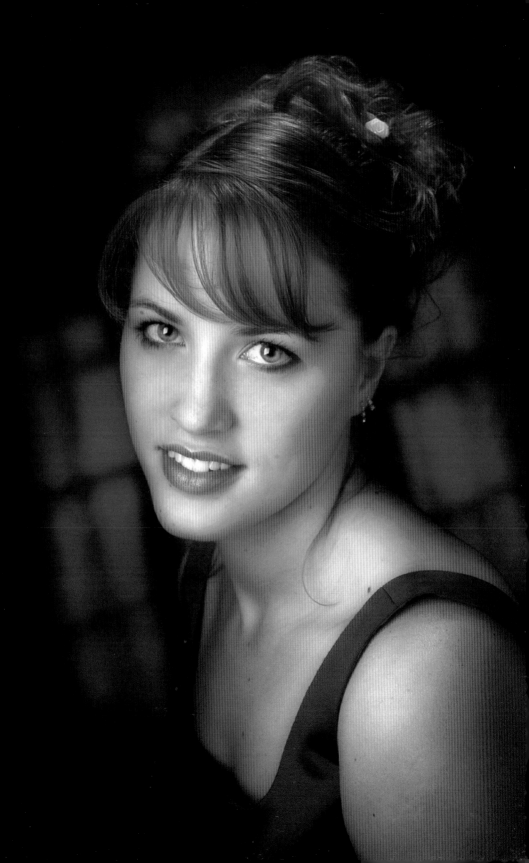

David LaClaire says he has often thought about the significance of personal portraits and has been encouraged when families of subjects later deceased (not applicable here) asked for new prints.

the person to turn and tilt his/her face in all directions. You can gently banter about it as you observe how changing the angles of a face pleases or disappoints the camera. However, never even hint that someone's face doesn't photograph easily. If you have to struggle to find a pleasing angle, explain that you are looking to make the person really beautiful or handsome. As you change facial angles and camera views, modulate the lighting effects that the camera sees.

Camera Angles. In addition to asking someone to tilt his/her face up, do the same with the camera, preferably one set on a tripod or stand, to preserve whatever graceful results you see that may save a sitting. Tilt both the face and camera in subtle movements that you can evaluate. Change poses and lighting carefully. Keep talking—the customer may wonder why you seem hesitant, so the more gently you suggest facial movements and indicate that you are seeking benevolent camera angles, the more relaxed the individual may become. Stay calm and try to sound sensitive as you make a series of posing suggestions and take a series of

pictures. Don't stop to share results in the camera's LCD finder or on an adjacent monitor, because peeking may break your soothing rhythm. Continue to discover angles and lighting that do pleasant things to faces,

The man's face inspired Anthony Cava to suggest this pose and light it strongly from above. "I try to avoid typical poses," he says. "In a very competitive market I find being different is by far our biggest selling factor."

ABOVE—Anthony Cava added elegance to this family portrait by asking them all to dress in black, lighting them from the front with a background of subtle stripes. All three generations were pleased. FACING PAGE—While photographing a striking woman, Brian Crain took her outdoors for a change of pace. He says, "I feel that catching a woman's appeal with a sense of fashion keeps me prominently in the minds of brides."

photogenic or irregular. Watch background lighting during your portrait activities.

Lighting Angles. As the face and camera adjustments progress, adjusting lights on a stubborn face should continue in harmony with nimble conversation. Place the lights—left, right, in front, behind—in whatever position promises solutions to your portrait problems. Some movements may be just psychological gambits to show a subject that you are being inspired. Conversation can be somewhat hypnotic to individuals who are certain they don't photograph well. Distracting the not-so-photogenic person can lead to facial expressions not otherwise realized. Assure the person that all the moves you are making are aimed at creating beautiful portraits.

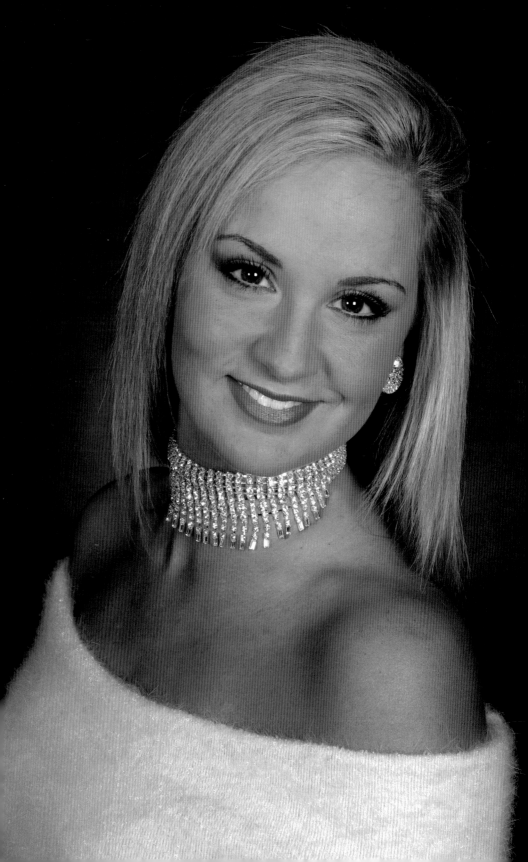

ABOVE—Robert Arnold hired this model for a cologne ad, and the client chose the profile pose. Robert paints wall backgrounds with a sponge and latex paint. FACING PAGE—Working with designers, Brian Crain photographs models wearing their creations. Here, a softbox at each side created even lighting, and the black background added contrast behind a warm-toned model.

While you are maneuvering main and fill lights, consider shifting the background light or lights to increase or decrease contrast between the person and the background you choose. Switch backgrounds when you feel another would more effectively complement the subject. A dark background can work wonders behind some people.

Follow Through. You don't want a subject to be very involved in the process, certainly not making suggestions, but you do want him/her to understand how conscientiously you have been trying to enhance

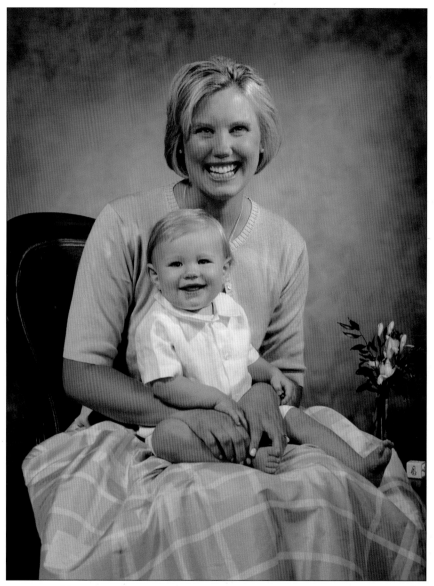

ABOVE—In his studio David LaClaire photographed celebrities and other subjects, such as this young mother and her happy child. "I tried to keep the lighting as though they were at home, as opposed to more dramatic effects I might use with showy individuals," he says. FACING PAGE—Moody, thoughtful, and arresting are words that describe Brian Crain's striking portrait of a woman in a dark blouse that sets off her face. He used one softbox, placed in front of the subject and to one side, which you can see reflected in her eyes.

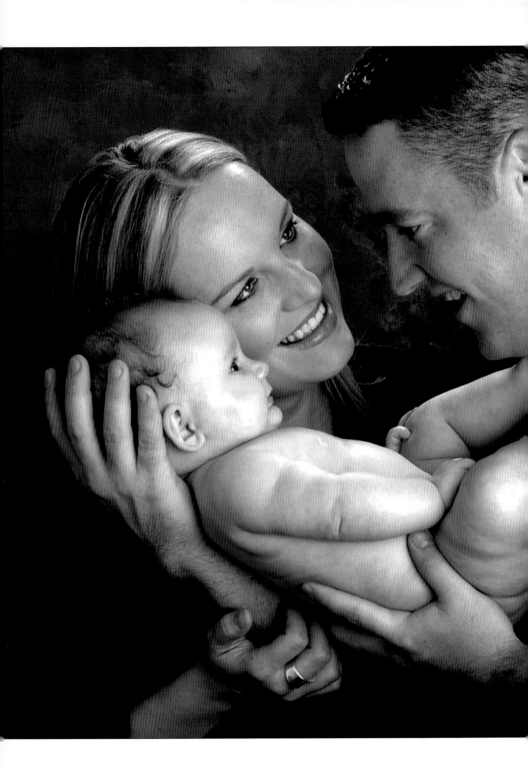

LEFT—Personal and endearing is this image of a lovely couple adoring their infant. Frank Frost's main light came from the right, and he used a hairlight on the woman. He offered directions and captured a decisive moment. ABOVE—Baby twins did not daunt Laura Cantrell, who posed them in a period chair in period dresses with their mother off camera to keep them amused and feeling secure. Daylight from a studio window was augmented by a reflector.

him/her in the portraits you are shooting. However, there is no need to exaggerate.

When you sense a time to stop, and if your system is so designed, you can go to a nearby monitor, choose some of the best portraits, and display them one at a time. If that's not your arrangement, make a

few nice proof prints of choice poses for the customer, whose confidence in you will be improved if you do go back to shooting. Photographic creativity is exercised through digital controls that make your work more enjoyable.

O VERY PHOTOGENIC FACES

You're in heaven with a face that can't be distorted no matter how you view it in the finder. You may maneuver lights, tilt the face, and change camera angles as described above, but the images are more rewarding. Even if your subject is not a perfect model, a face that looks pleasant or beautiful in many poses is fairly easy to light and is an inspiration. Photogenic faces, however, make your efforts seem more productive. Finely featured people may also need fewer suggestions for posing, and your photography may seem easier. Beautiful people compensate for other faces, on which you may have to work harder. But remember, with

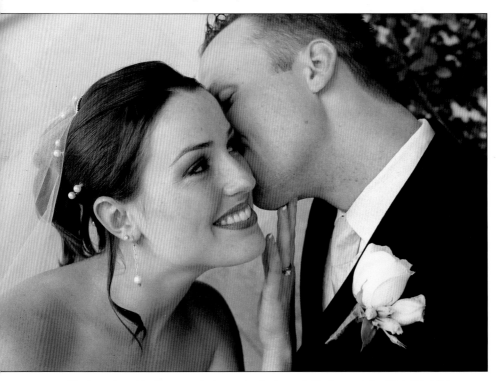

Photogenic subjects are a photographer's dream! Photograph by Dina Douglas.

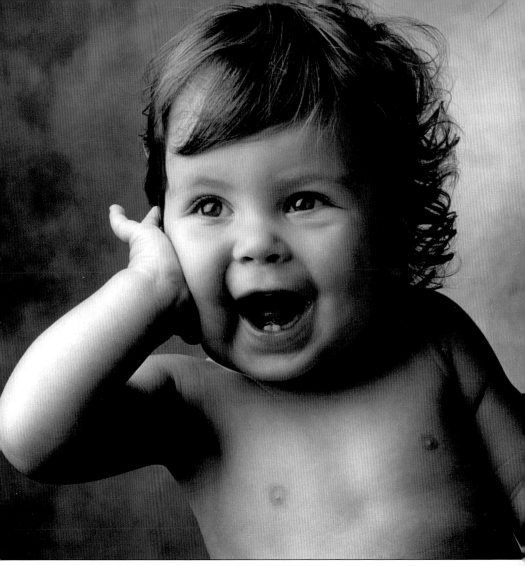

Robert Arnold photographed an ad agency executive's fourteen-month-old child as part of a portfolio of images as a Christmas present for the client's wife. Photographer and father cajoled the youngster.

all your subjects, you are in control, and digital portrait photography can stimulate your portrait techniques.

○ POSITIONING LIGHTS

Lighting may be kind and gentle on a face, or overlapping and confusing shadows may make a face seem "chopped up." When you light a

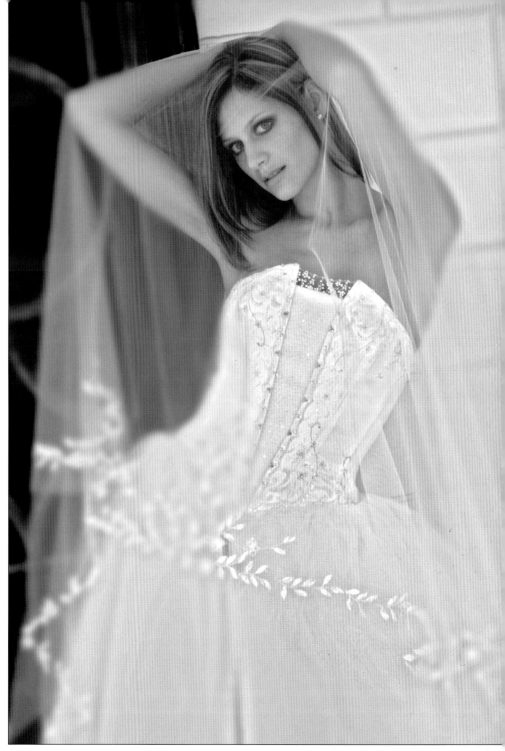

Sometimes high contrast lighting is desirable, such as in the image on the facing page where it adds a sense of drama and attitude. Other times, lower contrast is preferred to produce a softer, more feminine feel—as in the image above. Both photographs by Brian Crain.

While portraits of moms and babies are common, Robert Arnold's charming images of dads and babies (above and facing page) show that fathers make great subjects, too.

portrait or a group of people, where do you want shadows, where do they not belong? How strongly do you want to show form and lines in a face? Where you place the softbox or umbrella as main and fill lights depends on the subject's facial features and your personal taste. Experience shows you the way. Portrait lighting can be dramatic, subtle, or in between. Finesse the lighting to suit the face.

Fill Light. Not every portrait needs the same amount of fill light. As you shoot, distinctive highlights and shadows may grab your attention more than softer lighting that is more artistically acceptable. Subtle light-

ing is appealing and flattering, though glamorous faces may have a shadowed side or distinct shadows.

○ THE JOYS OF DIFFUSION

Softboxes and Umbrellas. Study portraits everywhere—in magazines, newspapers, books, advertisements, movie posters, in portrait studio displays, etc.—and you will see several lighting styles. Mostly light will be soft, diffused by softboxes and umbrellas. Published portraits are often lighted dramatically with dark shadows, or they may be high key, almost shadowless. Portraits are illuminated for various effects, often to glamorize the subject, and always to please him or her.

Smaller reflectors may be handheld, while larger ones can be mounted on stands. Homemade reflectors can be fashioned from white foamcore or illustration board. Some manufactured reflectors fold to carry easily. Photographers like reflectors because they are easy to maneuver, and large ones can cover a whole figure. With an umbrella, softbox, reflector, or all three, shoot some diffused light experiments and compare the results to determine what works best.

Theatrical vs. Softer Lighting. Theatrical lighting is an edgy lighting style that appeals to many clients. Most clients prefer pictures that

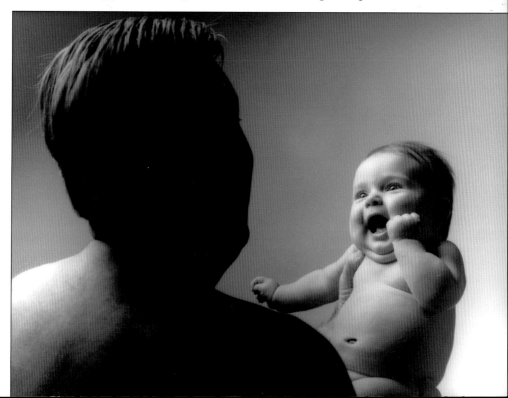

make others exclaim, "You look beauti-
ful!" or "It makes you look like George
Clooney." However, experience shows
that lighting in a majority of good por-
traits is diffused, resulting in a softer look.
This is reflected light, or light that comes
through layers of gauze. Shadows are soft-
ened depending on your taste and the
design and size of your softbox or
umbrella. Custom-made softboxes with
additional diffusing materials for even
softer effects are available. Umbrellas
lined with white, silver, and gold soften
and tint the light. Soft light is prettier.

⚪ BACKGROUNDS

If you have a handy way of hanging
fabrics and ready-made backgrounds,
whether from a rack, a roll-down system,
or fastened to a wall, try changing the
background at least once to achieve
greater variety. I like to change the color
behind someone, because it changes the
visual mood. You could also switch from a
bright or dark color to white or off-white.

When people change clothes for a different portrait look select a new
complementary background.

As mentioned in an earlier chapter, commercially made backgrounds
offer great variety. Some on canvas are heavy and require a sturdy sus-
pension system. Carefully chosen fabrics also make excellent back-
grounds. Look for those that don't tend to wrinkle easily, and mount
them on rollers to adjust their position. Dark blue, red, or orange-brown
backgrounds are often pleasing. Try to avoid patterned backgrounds
that compete with the subject.

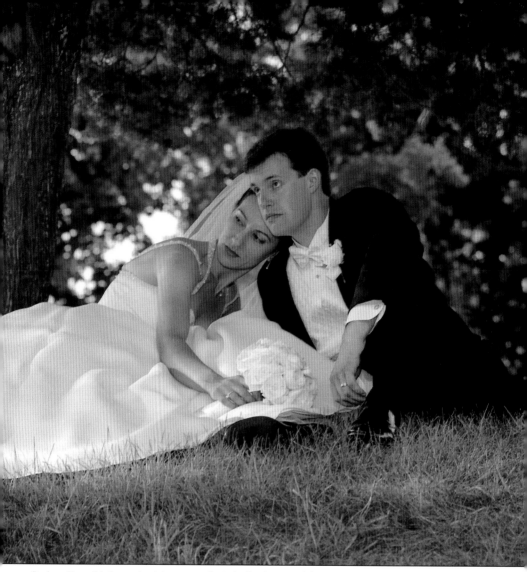

On location, it's important to ensure that the background doesn't distract from the subjects. Photograph by Tommy Colbert.

Backgrounds are usually flatly lighted, though some are artistically shadowed. One light from the side or from below or lighting evenly from both sides will do it. You may also want the background to be graduated from light behind a subject to darker at the top and sides. Check the background with a flash meter and adjust the lights for proper exposure. It may sound tricky, but it's not. Occasionally I use warmer hot lights on a background with flash on the subject for a change of pace.

⊙ CLOTHING AND MAKEUP

Some photographic studios suggest that people bring one or two changes of clothing for portrait variety. This is useful with people who are not sure what to wear. Recommend that people avoid busy patterns, clashing colors, and whatever might distract viewers from enjoying their faces. Plain, bright colors can be okay. Before the sitting or when the client arrives, review clothing with him/her and help make suitable choices. During a session, especially with teens, plan to allow the client time to change at least once for variety. When in doubt, several changes of clothing can save the day.

> When in doubt, several changes of clothing can save the day.

As for makeup, women should be made up when they arrive at the studio and, if anything, only touch-ups should take any time. If you feel that makeup is too garish or there's not enough, tactfully discuss it with the subject. If a woman uses no makeup, you might suggest that a little not-too-bright lipstick can be a useful accent in portraits.

⊙ POSING

Sitting, standing, reclining, leaning with chin on hands, and various other positions can be appealing poses in a portrait.

Many photographers have a standard or typical way to begin posing at sessions—often seated, turned three-quarters to the camera with the head turned slightly so the eyes can look into the lens. This is usually a more interesting pose than one in which the client is positioned square to the camera, and it offers the opportunity to have the subject lean slightly toward you and to tilt his/her head one way or another.

Depending on the length of a session and on the subject's ease, various poses will evolve. If the person is fairly young and limber, reclining on a couch or on the floor with pillows can make for good posing

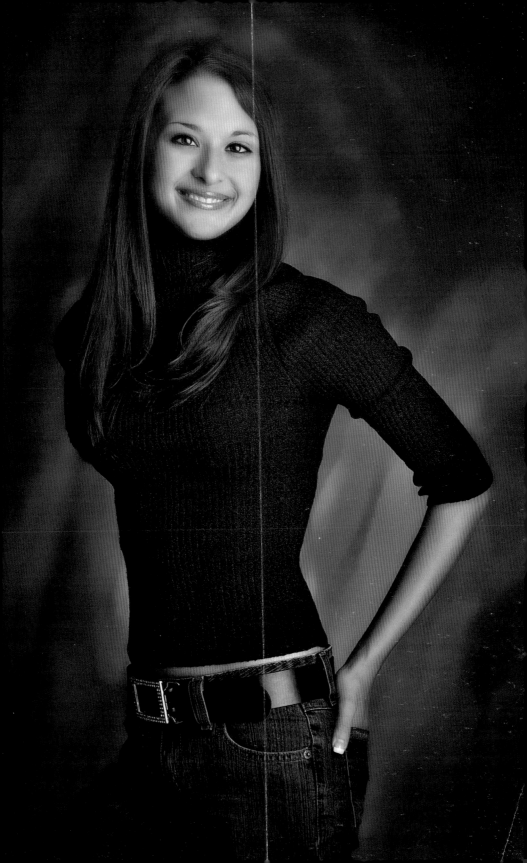

options. Also, having the client seated in an upholstered chair with his or her legs over the arm is a possibility.

I usually start with a three-quarter pose but find that poses depend on the age, character, appearance, and disposition of the person. Some people pose naturally on their own. I position the camera according to whim

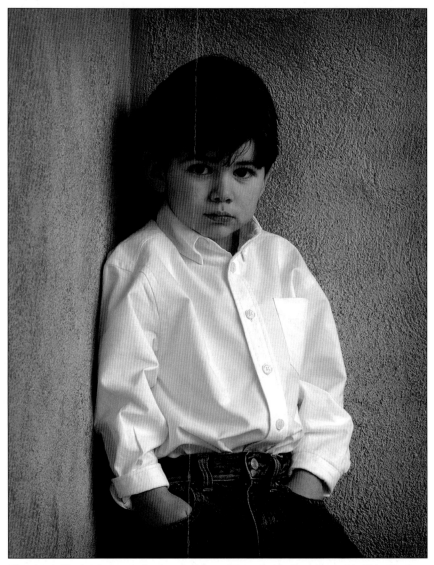

Classic clothes and a casual pose combine with a simple background in this timeless portrait by Anthony Cava.

and expect people to twist or turn spontaneously and with suggestions. Change poses to discover facial views that appeal to you as you go along. Direct and expect facial expressions. To stir things up, when your set is clear enough, try some jumping shots. The late Phillipe Halsman, who shot dozens of Life covers, asked each of his often-famous subjects to jump at the end of a session. *Philippe Halsman's Jump Book* (Harry N. Abrams, Inc., 1986) shows 191 celebrities, captured in midair.

More Formal Poses. Older people often prefer more staid poses. You probably won't be tempted to try anything tricky or unconventional unless you sense that they want something different. Then try a head-to-head pose with couples, and pose individuals with one shoulder aimed at the camera. Do it with the camera at varying heights. No matter a client's age, experiment with poses and they may be surprised. Unless a pose looks awkward, if it intrigues you, shoot it.

Creative lighting effects will add impact to posing alternatives.

Unconventional Poses. These may just evolve, or you can stimulate your imagination by using props, furniture, or even clothing that lends itself to a more experimental look. Photograph someone in a prop frame, or in a garden set that adds atmosphere. Or go on location to a garden or outdoor spot.

Couples in a wide range of ages may be eager to try your offbeat sets and poses. Face to face, head to head, arms around shoulders, one person in the crook of the other's arm—these and more poses can charm clients. Creative lighting effects will add impact to posing alternatives.

For more guidance on posing, refer to *Master Posing Guide for Portrait Photographers,* by J. D. Wacker (Amherst Media, 2001).

⊙ PICTURE-TAKING TIPS

Here are some suggestions for great portraits with a minimum of stress:

- Handhold the camera if that's comfortable. You'll be more flexible and can quickly make compositional changes.

Look for a prop or helper to keep little ones roughly in place, then wait for the right moment. Here, Frank Frost used the dad's hands to "pose" the infant.

- Using a tripod, remember to change camera angles regularly. A ball head on a tripod is a boon to adjusting the camera easily. This leads to more portrait variety.
- Before I photograph anyone, stranger or friend, I take a few minutes to get acquainted. Time spent getting to know the subject helps make the session more fluid. Inquire about aspects of someone's life that aren't too personal. As you shoot, continue casual conversation. Compliment people's looks or clothing frequently without overdoing it. Avoid discussing politics or religion even if the subject initiates the topic.
- I often tell people that I change the lighting to make them look more appealing. I avoid the word "better" so they don't wonder how awful they looked prior to the change.

- Keep the conversation relaxed. If the subject talks too much, when you want to give directions, ask cheerily, "Can I have a moment of your time?" Direct the conversation, and pace the verbal exchange to suit your working habits.

A teen ballerina happily stayed on pointe for Frank Frost, who was delighted to find a neat way to enhance the young lady's portfolio.

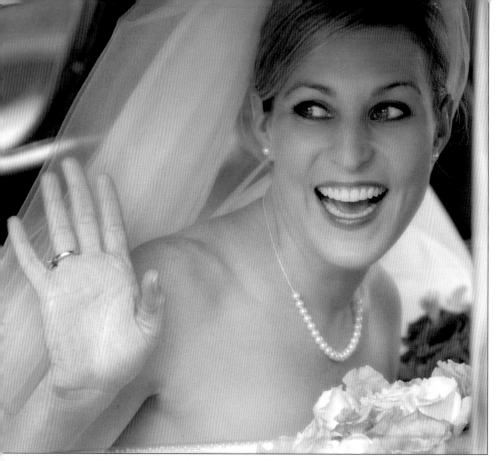

Sometimes, great poses happen right in front of your eyes—but you have to be ready to capture them! Photograph by Tommy Colbert.

- When you adjust the lights, remember the lighting patterns and poses you have just used. When you take a flash exposure reading, you may mention what you're doing and why. I believe this kind of sharing helps put the subject at ease. You are working together for beautiful pictures, and keeping the subject informed supports the positive feeling of being a team.
- While trying to light softly, avoid creating crisscrossed shadows that can cause visual confusion. Place a light on each side, with one at a greater distance and different angle than the other. If you use a softbox in front, the shadow it produces will be minimal. You will be surprised how successful some of your portrait lighting arrangements will be.

- Set lights to make the shadow side half as bright as the highlight side (a 2:1 ratio) for a nice portrait variation. Only mention technical stuff when you want people to know how involved you are in their pictures.
- While taking portraits, the subject is the star and you are the director. You'll continually ask the subject to turn slightly, tip their head, twist a shoulder, part their lips, or smile. Observe, wait for poses and expressions that you feel are outstanding, and get the image. Your aesthetic perception of how eyes, nose, chin, and the entire face appear is what you are being paid for.
- Depend on intuition and experience to shoot and capture fleeting expressions. Naturally, no matter how sharp your perception, some

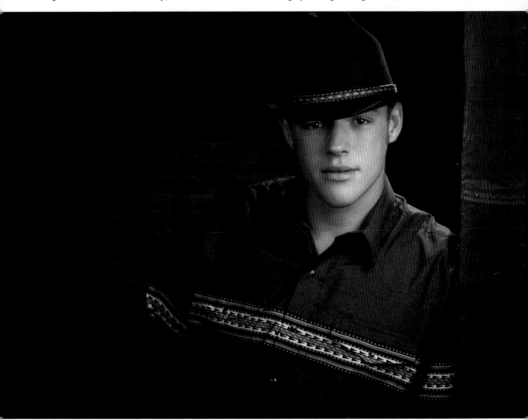

Notice how everything in this country-style portrait coordinates—from the clothing selection, to the background, to the pose. Photograph by Kurt Brewer.

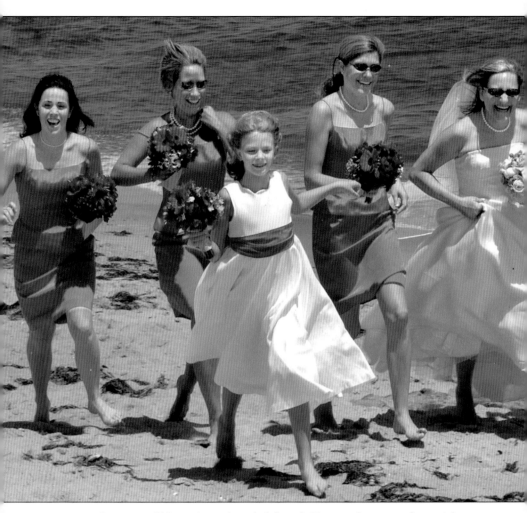

pictures will be rejected and deleted. Every photographer with professional standing throws away some pictures, and this means your customers will choose from only the best images. Your talent and taste are approved after every sitting when happy people will receive excellent photographs.

• When a subject asks to see their images on a monitor or the camera's LCD screen, have them wait until you're ready for a break. Then scroll through pictures to show an assortment, preferably on a monitor, but limit the time. You and the subject need to stay in a "portrait mode."

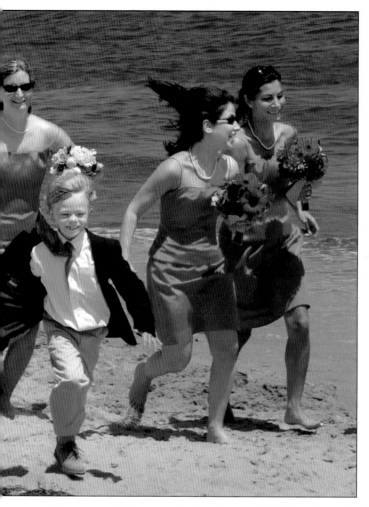

As you can see in this dynamic wedding image, sometimes a posing command can be as simple as, "Go!" Photo by Tommy Colbert.

- Be aware of the way the background is illuminated when you move lights. Adjust lights for pictorial variety. Behind the dark side of a face, lighten the background. Darken the background area behind the brighter side of the subject's face.
- Vary the apparent distance from the camera to the subject by zooming the lens. You can make changes gracefully without distracting the client.
- To reposition one person or a group, step out from behind the camera and direct them to new poses. This helps maintain closer contact and promotes confidence.

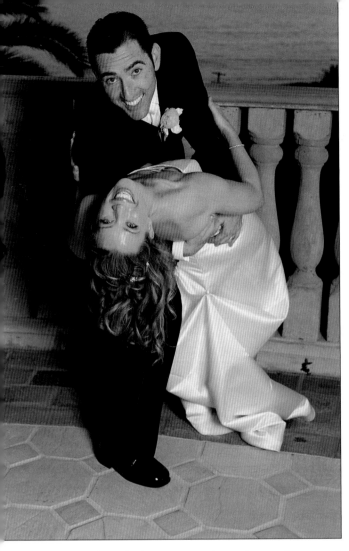

Don't be afraid to try unusual or unexpected poses. Photograph by Dina Douglas.

- When there are props in a picture, be sure the subject is dominant. Switching from a vertical to a horizontal format can help you to crop out part of an object in order to make it less visually important.
- People are capable of at least four expressions: smiling, laughing, lips parted pleasantly, and serious, with their lips closed. There are umpteen forms of smiles and laughter, so encourage serious or stern-looking people by cracking a joke or commenting on their dolorous expressions. There are countless varieties of parted-lips, all of which I like better than a too-serious look. Rejoice that human faces can be so fluid and expressive.

- Some studios play music to help people relax. You can choose music that helps you work or focus on the client, leaving them in charge. If you like classical music as I do, and the subject does, too, Gershwin or Chopin selections are beautiful and relaxing.

○ AFTER THE SESSION

When you finish a portrait session, transfer your image files from your memory card to your computer where you can review and edit them. Be sure to save copies of the original files before making changes to them. Once the editing process is complete, burn the enhanced files onto a CD. (Create a separate disc for each sitting.) Author Jeff Smith puts it this way: "CDs are your new negatives. You'll burn dozens of them and, because time is money, the faster the CD burner, the better. We use writable, not rewritable CDs because they are a permanent, unchangeable storage medium." CDs are inexpensive when you buy them in volume packs at electronic or club stores.

Jeff Smith continues, "Time is money, so download time is important. . . . There are two types of interfaces that professional-quality cameras use, FireWire® and USB." The former is faster, he says, and that's essential when you shoot a lot of pictures. If your PC does not have a FireWire port, one can be added, but USB may be just fine, depending on your volume.

Save copies of the original files before making changes to them.

You don't necessarily need to wait until the session is complete to download your images, however. In chapter 5 you read that Doug Jirsa's camera is wired to a computer in the camera room. As he takes pictures they are instantly downloaded to the computer. You can make the same arrangement. In his book *Digital Portrait Photography* (Amherst Media, 2003), Jeff Smith writes, "Many photographers find this to be the most efficient and safest way to shoot digital. . . . The image is stored in two places . . . on the memory card and on a hard disk." If you wish to add this feature to your setup, consider having a technician do it to be certain it's done right.

○ PHOTOGRAPHING CHILDREN

Many studio photographers specialize in children, a demographic that can be lucrative and fun. Those who enjoy it the most do the best kids' pictures. One photographer who does it very well is Laura Cantrell. She and her sister Lisa do a thriving business, for one reason—they have the knack. Portrait photographers who welcome mainly teens and grownups should consider making a separate shooting area for children—complete with props and toys. Do well with the kids and their parents will become clients, too.

Here are some enlightening quotes from Laura Cantrell, whom I interviewed for *Rangefinder:* "I shoot for expression first, and a child's hands can be quite expressive, too. Our studio has numerous props for

kids, and around here parents are also props, as they interact with the youngsters. Being with children is like reading a great new book every day. Each child is different, and my approach is modified accordingly.

"My assistant is trained to stand off-camera and prompt children to look in the right direction. We try to create a lovely environment that is age appropriate to give children a feeling of being in someone's home.

"We have a baby plan designed to illustrate the first five years of a child's life. The plan includes four portrait sessions, to be completed within two years. A portrait is

Outdoor scenes are quite popular for children's portraits—especially when paired with a cute summer outfit. Photographs by Laura Cantrell.

Comfortable seating makes it easier to pose kids. Photographs by Laura Cantrell.

chosen after each viewing and a matching set is printed at the plan's con-
clusion. Additional prints can be purchased at any viewing. It's become
a popular way to draw parents to professional photography."

Laura and Lisa have a "true passion," as Lisa puts it, for beautiful por-
traiture, and many families benefit.

Roger Rosenfeld photographed chocolate truffles with a softbox as a backlight and another softbox at right. Roger's client was Galaxy Desserts.

In the course of your portrait photography career you may be asked to shoot still-life subjects and products for commercial purposes. If a client asks to bring furniture, electronics, food products—or perhaps even fashion models—to your studio, be prepared. Models will be familiar. Still-life photography may be less so, but you should be comfortable because all the principles of lighting faces also apply to products or food.

Consider occasional commercial photography seriously, as a challenge, and because commercial and especially advertising jobs can pay well. If your studio is ready, your digital imaging system is also ready.

For more information on the technical aspects of shooting commercial images or products, see Dave Montizambert's book, *Creative Lighting Techniques for Studio Photographers* (2nd ed., Amherst Media, 2003).

⊙ PORTRAIT CONTRACTS

Most photographers I've talked to don't require portrait clients to sign contracts. However, there is an exception: before shooting a business group portrait session it is useful to have a company purchase order. Or a responsible officer of the company should sign your agreement, which should state the fee and down payment, deadline for delivery, and other specific conditions. In business, contracts are valued because they can help avoid hassles if someone has a complaint later. Check your draft of the contract with an attorney or ask him/her to draft a contract for you.

Also, before using a portrait in any advertising—whether in a printed ad or in a storefront display, in your studio or otherwise—be sure to obtain a release form. While you may technically own the copyrights, display is a form of advertising for which you need a release in writing.

7. WEDDINGS

○ A WEDDING CAREER

Not all portrait studio photographers shoot weddings, and not all wedding photographers choose to be portrait professionals. Those decisions are understandable. Running a successful digital portrait studio can take all your time, even if you are resourceful. Operating a digital wedding photography business is also time consuming, and some wedding specialists don't have studios. They photograph brides and couples on loca-

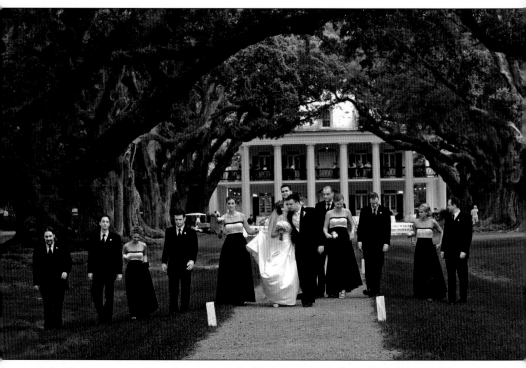

Brian Crain was arranging this group in fashion-magazine style and caught the bride charmingly whispering to the groom. He persuaded the participants to move closer together for the pictures.

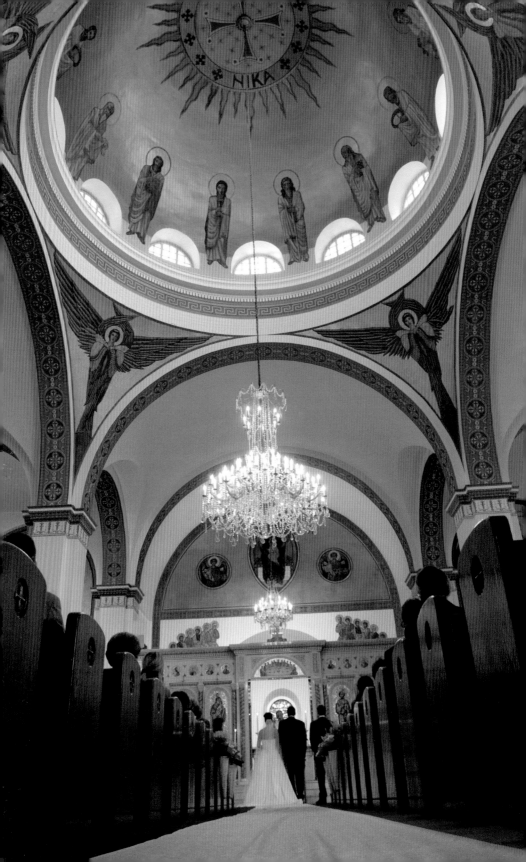

RIGHT—Brian Crain combined a luxurious setting and a willing bride for a lovely wedding day souvenir. He used one umbrella at 45 degrees at camera left and exposed to retain a relatively dark background. FACING PAGE—Tommy Colbert captured the bride and groom in the church with his camera and wide-angle lens on a tripod a few feet above the floor, and made the exposure in existing light. It's the kind of unusual coverage that most couples really appreciate.

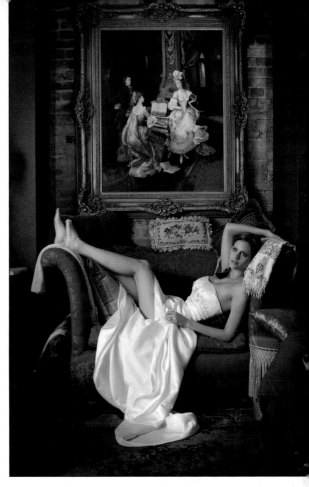

tion or in an area at home that's adjacent to an office. Just-married formals may also be photographed after the wedding when spontaneous joy is abundant. Because wedding photography can be quite profitable, some photographers conduct their planning for wedding sessions during the week, then photograph on weekends.

In their book *Professional Techniques for Digital Wedding Photography* (2nd ed., Amherst Media, 2004), Jeff and Kathleen Hawkins suggest that you sell your clients on the advantages of digital wedding photography as a phenomenon from which beautiful photographs result. Many future brides have experienced their friends' and relatives' weddings, so they are already sold on the benefits and quality of digital imagery. Couples may choose traditional picture coverage, though photojournalistic wedding photography is also popular. Whatever your style, when couples see samples of your work, they will realize that you understand the nuances of picturing weddings with skill and fine timing. Studio portraits and on-location wedding coverage can make a neat combination.

In the wedding field, a website can be your number-one marketing tool. Hire a good designer to create an attractive site that shows off your images to help set you apart from the pack. My friend Dina Douglas, who has much more experience shooting weddings than I do, also stresses the importance of building a good portfolio of work. "Getting started, assist other photographers," she suggests, "for free if necessary, to have a strong collection of images to convince people of your ability to please them. They'll more easily accept your prices then."

○ PLANNING THE SESSION

Photographing weddings can be physically challenging because you are frequently on the move. There's an important reason why wedding pictures need to be planned: your coverage is really a picture story. I plan the pictures in chronological order. I'm talking about "average" wed-

The bride in the chair (page 145) also posed for Brian Crain on a leopard-skin background. When a bride is stressed at her wedding, Brian dreams up photo situations where she can relax and look great.

dings (if they exist) that take four to six hours. I'm also familiar with lengthy and expensive weddings, which may begin with newlyweds traveling by horse and buggy to the church. In situations like these you'll need an assistant to help keep the pace for a day or more.

Dina Douglas says, "Photographers should work with the bride to create a schedule that allows enough time to capture the images he/she knows the bride and groom will desire. Many brides may only want to allow about half an hour for group shots, even for large weddings. And they may not leave time for bride-and-groom portraits, but a good photographer knows the time needed and will work closely with the bride, educating her along the way, to ensure opportunities for all the pictures the couple will cherish later."

Dina adds this business note, "Don't try to juggle multiple requests to shoot on the same wedding date. It should be first-come, first-served

When Tim Schooler's daughter was married they enjoyed a photo session that utilized various poses and backgrounds. For the image above, she sat on the floor of Tim's studio while he spread her lovely skirt around her and gave her the rose to hold. For the portrait on the facing page, Tim posed her with a large window at right and captured her in enchanting back light, creating a sort of human cameo. Tim specializes in portraiture and shoots high-end weddings when they come his way.

once you have a deposit. There's no way you can 'hold a date' since you may lose out on another booking. New photographers should be firm about dates or they will learn a hard lesson."

○ COMMON SHOTS

The following are situations that most brides want photographed. More are listed than some weddings include, but it helps to be aware of such possibilities. Meet with the bride, her mother, and whoever else is in on the planning. Discuss everything they expect will happen on the wedding day and before, and list all the picture situations that you agree should be covered. Keep in mind that weddings can overflow with

What a great stage set! is what Dina Douglas thought as she photographed a happy couple just after their wedding. As they started toward her she ran up the steps to be ready to shoot a series of the pair smiling at guests left and right.

meaning and sentimentality, much of which you will capture. My own list includes typical wedding events and more:

- Before the wedding, bridal pictures can be made in a studio or on location. If the wedding will be outdoors, ask if the bride prefers to be photographed in a natural setting prior to the wedding. Use your posing and lighting skills to make her look glorious. Invite a good friend of the bride to help her relax. Seeing wedding pictures you're created for other clients prior to her wedding will help boost the bride's confidence about how attractive you'll make her look.
- Arrive at the wedding location an hour or two ahead of time. Set up lights if they are needed and test exposures with a stand-in. Learn

beforehand if flash is permitted during the wedding ceremony. When the wedding site is bright enough, set your ISO to 200 or 400 to get some natural-light pictures of the ceremony.

- If bridal pictures are planned after the wedding ceremony, allow time for enough poses. Ask the groom to help amuse and distract his new wife and vice versa. Shoot meaningful pictures of the couple together. Pictures of the bride and groom in church are often made in front of the altar. Use existing daylight when possible or studio flash units on stands—or both.

- If the wedding is held outdoors, hope it's in the shade and make test shots of a stand-in with and without flash fill. Plan ahead where individual portraits of the bride and groom, couple pictures, and images of the wedding party will be made. Have a short ladder on hand for better views of people in rows.

- In the same church setting that you photograph the bride and groom, assemble relatives and close friends, bridesmaids, and ushers

Each of the group wedding shots in this chapter has its own character. This fascinating assemblage by Dina Douglas has a lovely period look about it because of the traditional church background and sober expressions on some of the people. The image has its own beautiful symmetry.

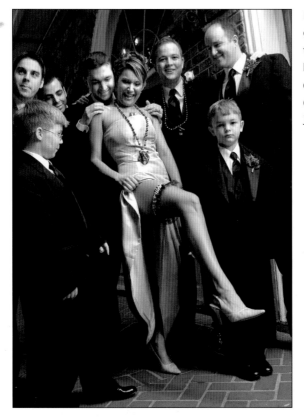

Brian Crain arranged this group after a wedding so the bride could show off her blue garter. The audience exhibited an amusing diversity of expressions, just as Brian expected.

for group photos. Indoors or out, ask a family member to help you arrange the people. Be ready with your flash and a tripod. Do the photography before people wander off to the reception.

- Depending on the size of the wedding and its location, consider employing an experienced person as an assistant for the day. Many times at weddings I've wished I could be in two places at once. An assistant's fee is embedded in the wedding charges.

- Photographing a wedding receiving line is a challenge because people crowd in front of the couple. Note also that the bride, her mother, and/or the groom may ask special friends and relatives to stop for quick pictures. You might ask the wedding couple for a list of VIPs they definitely want to be photographed with.

- It is inevitable at the reception and during lunch or dinner that groups and relatives from near and far will ask to be photographed

with the bride and groom, the parents, etc. If you need to photograph people at tables, stand on a small ladder and ask each person to face the camera. Remove a centerpiece that's in the way. As an alternative, ask those in front to stand behind those seated. While

Spontaneity is the key to successful wedding photography, especially in the photojournalistic tradition offered by Tommy Colbert. He was ready to shoot a series of pictures when the pigeons were released, and this was the best image.

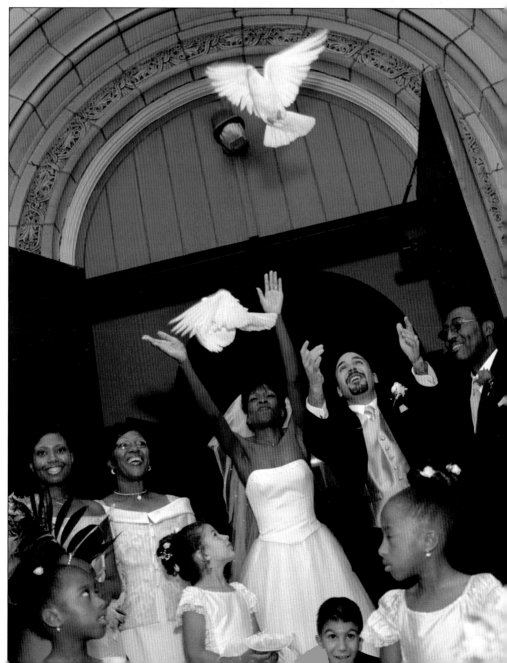

Tommy Colbert captured a moment of great animation—along with the many other candid photographs he made of their wedding that day.

you photograph, an assistant can arrange the people at the next table.

- If there is music and dancing after a meal, be sure to feature the bride and groom together and perhaps with friends and relatives. If there's a place to photograph dancers from above, position the bride and groom in the center, surrounded by other dancers. For some shots, ask the bridal couple to take a dancing pose while the others actually dance around them, and shoot at a slow speed for a decorative blur.
- After the guests have eaten, some will begin to leave—but you still have time to shoot whatever the newlyweds are doing, plus the bride throwing her bouquet.
- After the rice is thrown and the newlyweds depart in their car, try to relax.

Those are typical wedding picture situations. Remember to adjust the camera's white balance when you move from artificial light to daylight and flash, or vice versa.

○ BACK UP YOUR PICTURES

Many wedding photographers, for safety, back up their images by transferring them to a laptop between the major wedding events. After pictures are transferred to a hard drive, you can reformat and reuse the memory card. It's important to carry extra memory cards, because you can't predict when you will have image-transfer time. Don't try to modify original images; rather, wait to make any enhancements until the original files are safely saved on a disc.

○ WEDDING PHOTOJOURNALISM

The potential picture situations listed above also apply to weddings photographed in journalistic style. The difference is that many images of the bride, groom, and guests are "grabbed" when people are not posing. As a former magazine shooter, I use a spontaneous approach when appropriate. It's also okay to set people in motion for pictures that *look* candid. Direct them to be convivial and to ignore the camera. Shoot a range of interesting portraits and interactions and capture

Planning made possible an unforgettable setting that Tommy Colbert suggested. Friends in the wedding party journeyed with them to the sunset location and watched Tommy star the couple in a real sunset pageant.

elegant details. Try to photograph participants doing whatever the circumstances inspire, such as whirl around in a wedding dress or pose whimsically.

○ UNIQUE WEDDING SITUATIONS

Sometimes, it's the unpredictable moments that best chronicle special wedding moments. The examples in the list below will give you a feel for just those sort of unique moments you'll want to capture.

- A smiling bride walking in a field with some of the wedding party.
- The wedding party, in formal gowns and tuxedos, spending a moment on a sandy beach or at another offbeat setting.
- The bride and groom caught unawares, telling secrets or otherwise expressing themselves, sharing their joy.
- The bride and groom in a woodsy setting, full length and in profile (or not), adoring each other for posterity.
- A wedding group in their finery walking up a city street, because incongruity can be cool.
- Happy bridesmaids, holding bouquets, arranged in a pattern on a couch in a den or living room.

Of course, such opportunities can be orchestrated, too:

- Candid wedding photographers also like mixing tungsten and daylight for welcome warm tints.
- Plan some of your wedding coverage on location before and during sunset to capture mood and perhaps sequence pictures.

Many couples are enthusiastic about less formal types of digital journalistic coverage. Occasionally share what you're getting to keep people energized.

○ WEDDING PHOTOGRAPHY CONTRACTS

Because wedding photo fees often amount to thousands of dollars and picture requirements are numerous, both you and the participants should have a written agreement about your fees and what you will pro-

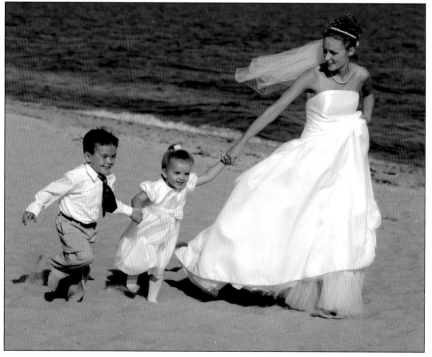

Tommy Colbert took the bride and children for an outing at the beach and produced this fine example of photographic incongruity that newlyweds enjoy seeing in their coverage. Tommy's website, www.tommycolbert.com, offers an instructive diversity of images and an article on wedding photography.

vide. These details are covered in wedding photography contracts. If a client seems reluctant to sign one, explain that a contract helps to protect them because it states what they will get for their investment. The terms of a contract should cover photography on location both at a church and other locations. Unusual circumstances should be clearly stated. Have an attorney check your contract to be sure it protects you and your clients properly. Attorney Tad Crawford includes a sample wedding photo contract in his book, *Business and Legal Forms for Photographers* (3rd ed., Allworth Press, 2002). Another can be found in *Wedding and Portrait Photographers' Legal Handbook* (Amherst Media, 2005) by Norman Phillips and Christopher S. Nudo, Esq.

Contract Terms. Here are the important points:

- Stipulate the dates, times, and locations where wedding events are to take place. You might want to state that special photo requests from the bridal couple or the family will be honored.
- State the amount of time you expect to be at the wedding.
- Detail the price of the coverage, and note what is included in the package and what is extra.
- State when payments need to be made. A nonrefundable retainer should be stipulated when the contract is signed. Many photographers require the final payment before the wedding ceremony. This protects you and enables you to conveniently pay production costs.
- In Ed Lilly's book, *The Business of Studio Photography* (Allworth Press, 2002), he suggests that the contract should cover the intrusion of third parties. This means if the bride and groom tell you

what they want, and parents paying for the wedding give you conflicting orders, the contract can stipulate whose desires you will follow.

- A contract may state that prints made from a disc included in your wedding package may not be published in any kind of paid advertising without your permission.
- Include a cancellation fee that states how much you will charge if the wedding is called off or postponed. No refund should be provided unless you are able to rebook the wedding date. You may have previously turned away other clients for that date, and you should not be penalized. If someone cancels even a month before a wedding date, it is unlikely that you will be able to rebook the time because most brides book months ahead.
- The contract should state that every effort will be made to capture outstanding images on the wedding day(s), but since some aspects of the day(s) are beyond your control, you cannot guarantee delivery of any specifically requested picture. A limitation of liability clause protects you in case there are unexpected problems preventing you from shooting certain pictures. The contract can state that no damages for negligence will be paid, but check this with your liability insurance company.

○ WEDDING ETHICS

You are usually not considered a guest at the weddings you photograph. When you ask people to cooperate in poses, do it tactfully, because all those people *are* guests. If you are asked by a guest to shoot pictures and there is time, fill the request gracefully. However, even if someone gives you a name and phone number, deliver proofs only as a courtesy and for potential profit. The bride and groom may want to order pictures for such guests.

Hospitality. Gracious brides, grooms, or parents often invite the photographer to enjoy a drink before a meal is served, and they may also offer lunch or dinner. Assure your hosts that you will be available to take pictures during the meal and will expect interruptions. You may be

Tommy Colbert photographed the entire wedding party charging toward the camera—a great action shot they'll all remember! The bride and groom were handcolored in Photoshop to keep the emphasis on them.

directed to a table or told to find an available place once everyone seems to be seated.

While you are shooting, and especially during lunch or dinner, people will question you about your work. Hand out your card when asked in order to encourage future business. Invite prospective clients to visit your website and your studio to view your work.

Unless your contract says you may leave at a certain hour, stick around until the bride and groom have gone. You aren't finished until you photograph them dodging rice and driving off in their car. Then you may pack up. Be sure to thank whoever hired you and tell them how much you enjoyed the gala event. Good manners go a long way in business as well as in social life.

O PROOFS

While couples are honeymooning there's time to make proofs in-house or at a lab. When the newlyweds return, proofs are ready to show in the studio, or they may have already been sent to the bride and groom. As

an alternative, Jeff and Kathleen Hawkins inform us in *Professional Techniques for Digital Wedding Photography* (2nd ed., Amherst Media, 2004), "Many of our clients actually view a selection of their images while on their honeymoon—from digital cafes all over the world. This keeps their excitement alive and gets them passionate about seeing the rest of the images."

For more on proofing, see chapter 10.

WEDDING WEBSITES

Newlywed couples can register their gift suggestions and photographs of themselves on www.WeddingChannel.com.

Another site, www.pictage.com, is an online system for viewing, selling, and printing professional images. The site will add a couple's online photo album for friends and families to view and place orders, ensuring that people who might not otherwise see your images can place orders. Photographers using the www.pictage.com service will also receive a listing on www.WeddingChannel.com free of charge. These sites offer opportunities to promote yourself and offer wedding clients extra services.

8. SENIORS

○ THE SENIOR MARKET

As a portrait specialty, photographing high-school seniors can be challenging and financially rewarding. In areas with enough high schools to provide a steady stream of clients, many successful photographers concentrate on them exclusively. In your vicinity, other portrait studios are seeking the same senior work, so you must promote your studio, offer specials to teens, and build a clientele based on running an attractive studio and your ingratiating personality. You also have to shoot portraits and poses that young people like so they will recommend you to their friends, some of whom may be seniors the following year.

When Frank Frost has the pleasure of working with a senior as photogenic as this young lady, he tries to feature her beauty in a variety of ways, using gentle lighting. A plain background is often appropriate.

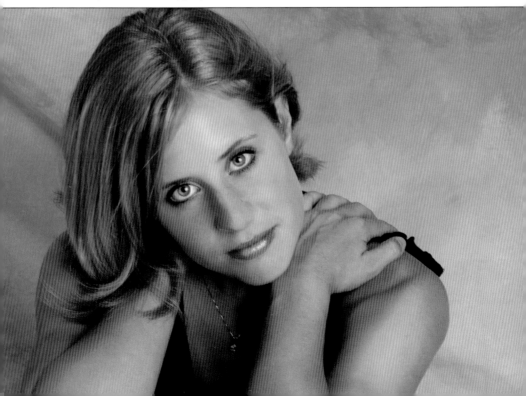

Rick and Deborah Lynn Ferro posed this young woman with her favorite saddle, which made her feel comfortable and became a wonderful prop. The dark background added a touch of glamour that the subject enjoyed.

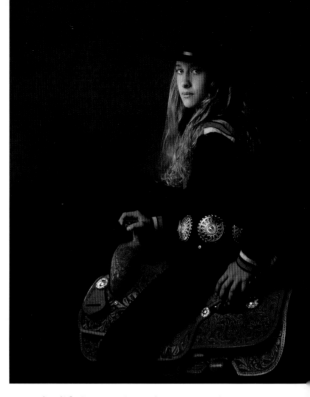

Diversifying. It's also cool for your studio to photograph grownups as well as teens. When you diversify, you tap into the whole population as portrait clients, and if you're like me, you enjoy the variety. Parents whose pictures you take may send you teens, who come in all shapes and attitudes, to make life interesting. At some point you may decide to build your senior clientele, and perhaps specialize in seniors, or maybe children also, if there are enough of each to grow the business. Phase into a single category because you enjoy it and it's proved profitable.

In any case, make yourself known to the whole metropolitan area via a website, as discussed below. Chapter 11 presents ideas for promoting yourself as a neat person who does appealing pictures in a studio with a variety of props and backgrounds, some of which may be small sets.

○ SEEKING SENIORS

High-school students may have first come to your studio with their families, and later alone as juniors or seniors for portraits. Make sure your whole clientele realizes you love to shoot senior pictures so they will enjoy the experience and show off their pictures. The following paragraphs outline some of the approaches you can use to draw seniors to your studio.

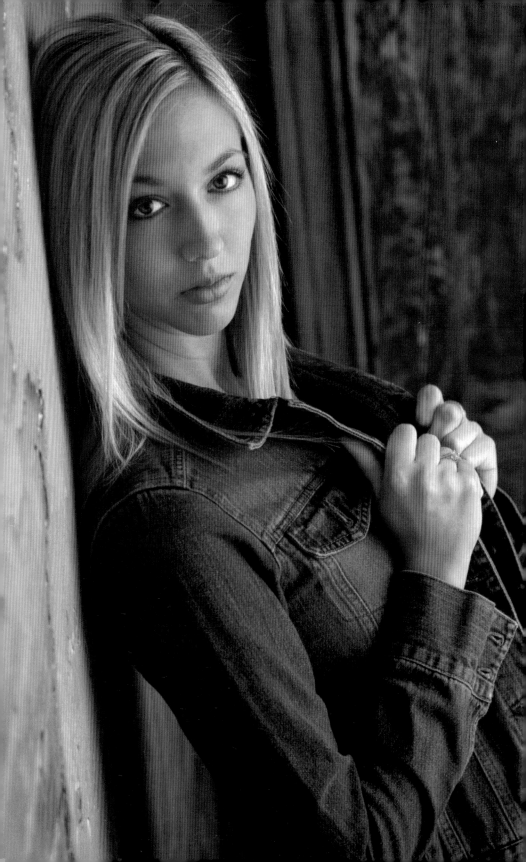

Websites. Young people are hip to all sorts of websites, and they may look for "portrait photographers" as a category. If they are good researchers, they will find you, but help them out with ads that include your web address in school newspapers. They may also get your name and web address from friends or find it in the yellow pages. Be familiar with what teens are finding on numerous attractive senior portrait websites when you set up your own. Consider dividing the presentation into sections such as yearbook pictures, graduation pictures, and special offers. In each sector should be samples of your images that can be enlarged by viewers. If your words and pictures are persuasive, young folks may check your prices and call for information and appointments.

Yellow Pages. This is where traditional parents may look first. Some teenagers may also search the yellow pages and discover your good-looking ad. Be direct and ingenious and not too modest. Advise readers to check your website or to call to discuss senior portraits.

Newspapers. Advertise in a local weekly newspaper, offer special packages, and quote prices. Young people and their parents are likely to be looking for bargains, and your ad could catch their eye.

Flyers. Have special advertising offers printed on a flyer that can be slipped under parked automobile windshield wipers. Use a couple of top-notch pictures and keep the copy short. List your web address, street address, and phone number. Seniors will find you.

Proms. Another way to publicize yourself is to arrange to photograph couples at high-school proms. You won't have much time then to get acquainted, but you can hand out flyers and business cards that may inspire some teens to call you. Try to have something unique at your studio like games, posters, good magazines, and a TV with videotapes of you at work. Intriguing teenagers is a skill worth developing.

● PROPS, BACKGROUNDS, AND SETS

This subject was covered in chapter 5 at greater length. A digest follows.

LEFT—This young man preferred to be photographed outdoors and asked to include his favorite guitar. It was a bright, overcast day and I used flash fill on the camera. We did a number of poses and camera angles while talking a lot to help him loosen up. FACING PAGE—Brian King enjoys working where there's a large window and often angles the subject so he can look directly into the light. This young man had a rather intense look and included it among his choice selections, which pleased Brian. Young people often feel that black & white images are cool.

Props. Look at other photographers' websites for examples of props used by competitors. Also, find out if a teen plays a musical instrument and ask him/her to bring it as a personal prop.

Backgrounds. It's easy to find photographic background paper in different colors to hang as backdrops, though a plain white wall is popular, too. Background paper is available 8 feet wide (or more), and large photo supply stores may stock it. When a portion of a roll is soiled, cut it off and pull down a clean section. I keep handy red, green, sand-color, and blue paper rolls, as well as pastel fabrics from specialty shops.

Sets. I haven't bought commercial studio sets because I prefer outdoor settings when weather and light are appropriate. On wet, cold, and dismal days my indoor locations are welcome. You could arrange a set or two with furniture, etc., to simulate part of a room, or buy a table to lean on or improvise something original. Sets and props that appeal to seniors are illustrated in the Denny Manufacturing Company Inc.'s catalog (see Resources). You can also make props, backgrounds, and sets yourself if you have the time and talent.

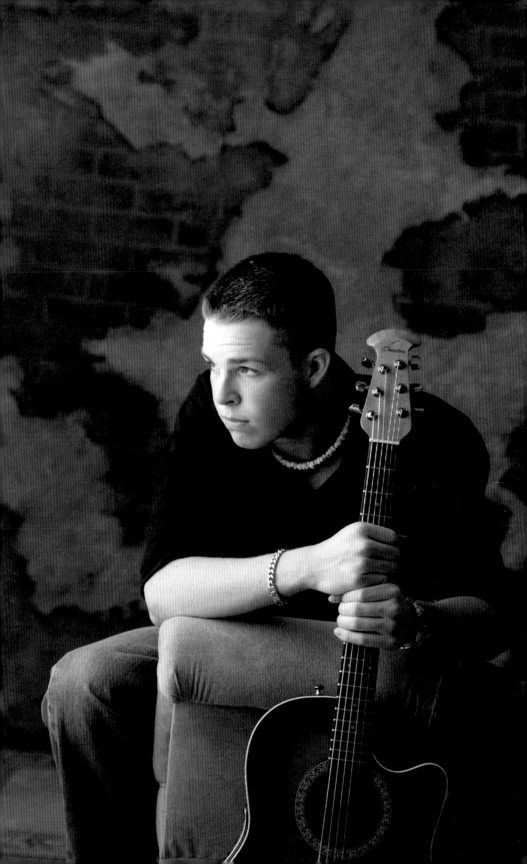

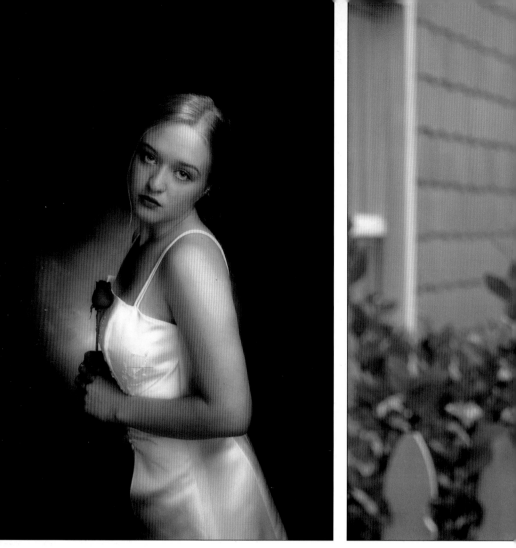

LEFT—Kurt Brewer gave this teen client the guise of a silent-movie star, complete with a halo of light behind her and a single rose. Many teens enjoy playing roles during their portrait sessions. RIGHT—A simple trellis was used in the foreground with a picket fence in the background, creating a nice sense of depth in this teen's portrait. Photograph by Deborah Lynn Ferro.

○ CLOTHING

Before the session, ask clients to wear what they wish and bring along alternate shirts, blouses, and pants. Suggest that they be themselves, and when their choices are somewhat outrageous, take some shots, then suggest they change to more suitable garb. Explain that wild clothing pat-

terns are taboo because they compete with faces. Define what colors and variations you feel will make them look best. If they bring hats, T-shirts with slogans on them, or bizarre outfits, consider saving them for last. Teens will respond to directions as well as free choice.

O POSING

Teenagers are more limber than many grownups, and they can twist into positions that would cause me pain. Otherwise, some senior posing variations are similar to posing their parents and families. Portrait positions can be numerous and varied because teens can be receptive to offbeat

photographs. Be versatile and encourage teens to suggest less conventional poses, but do some conventional ones, if just to keep their folks happy.

Teens enjoy being photographed with props and in sets, so go along with whatever seems appropriate. Talking to teens can be more spontaneous and fluid than speaking with adults, and they might enjoy the freedom of coming up with their own poses—unlike many grownups, who typically want direction.

○ PSYCHOLOGY

I can ingratiate myself with young persons by explaining what I'm doing as I work. When I move lights or change backgrounds, I suggest briefly that I'm trying to make the client look pretty or handsome or attractive. Try not to talk down to teens. Ask questions about their ambitions, what they have been reading, what kind of entertainment they prefer, etc. Being really interested in their lives is a winning way to work.

Also, if your studio has a stereo system and you have a selection of popular CDs, ask what music your subjects want to hear, and play it quietly as background music. If someone wants it loud, tell them it interferes with your creative drive or that you need it quiet to communicate. I sometimes play classical music for adults who like it, so ask teens if they would prefer Rachmaninoff, Brahms, or Gershwin.

Frank Frost is fond of using a Larson Starfish, a curved softbox, for many of his portrait sessions. "You really can't beat it for beautiful wraparound lighting," he says. The young lady loved the dreamy feeling Frank caught in soft, even light.

Doug Jirsa achieved the kind of glamorous appearance that this teen appreciated when she shared pictures with her folks and friends. It helps to have a photogenic face to work with, but lighting and posing contribute to glamour as well.

O LIGHTING

There's no specific way to light younger faces, but you can sometimes be more radical and experimental with shadows and contrast. As an example, use a main light from one side with minimum fill light on the other. Notice actors on TV and in movies lighted that way to enhance the mood of a scene. Seniors will also enjoy your efforts to glamorize or dramatize them by your lighting. Vary lighting and posing for young faces, which are often smoother and more flexible than some adult faces. Involve teens in your efforts and earn additional cooperation by showing your prints to explain how you lighted other young faces. Eager teens may suggest lighting arrangements that work.

O PREVIEWS

Some photographers show image previews on a monitor at convenient times during a sitting. Teens enjoy the showing and are able to choose poses they like best, right on the spot. When you have made a conven-

ient number of pictures to view, your photography is only interrupted for the limited interval you choose. When the studio computer is networked to your main one, the session can be pulled up and proofed while teen clients wait. Discourage them from wanting to see each shot just after it is taken.

● PRICING SENIOR SESSIONS

A number of other photographers publish their basic prices for portrait sessions on their websites, and this can work to your benefit. I have not quoted portrait and wedding photographers' prices in previous chapters because they vary so widely, and because prices change every year or so. However, here is an exception: check the website of Jeff Smith in Fresno, California who photographs only seniors. His portrait prices are a useful example. His web address is www.jeffsmithphoto.com. Here are examples of Jeff's fees for early 2005:

- *Ultimate Session*—forty-eight pictures, sixteen poses, eight backgrounds, four outfits, two hours for session and viewing, $59.00
- *Senior Session*—twenty-four pictures, eight poses, four backgrounds, two outfits, one-hour session and viewing, $39.00
- *Ultimate Folio Session*—twenty-four pictures, eight poses, four backgrounds, four outfits, sixteen pictures in a folio to keep, one-hour session and viewing, $109.00
- *Senior Folio Session*—twelve pictures, four poses, two backgrounds, two outfits, eight pictures in a folio, one-hour session, $89.00

● PROM PORTRAITS

Whether you are a senior specialist or not, consider contacting high schools in your vicinity to set up and photograph couples and individuals at prom locations on the perimeter of the dancing and celebration. Not all schools hold their proms on the same night, so your opportuni-

For this portrait, Tim Schooler combined a brick wall, receding out of focus in the background, and a casual pose. The result is a portrait that looks very natural and has a contemporary feel.

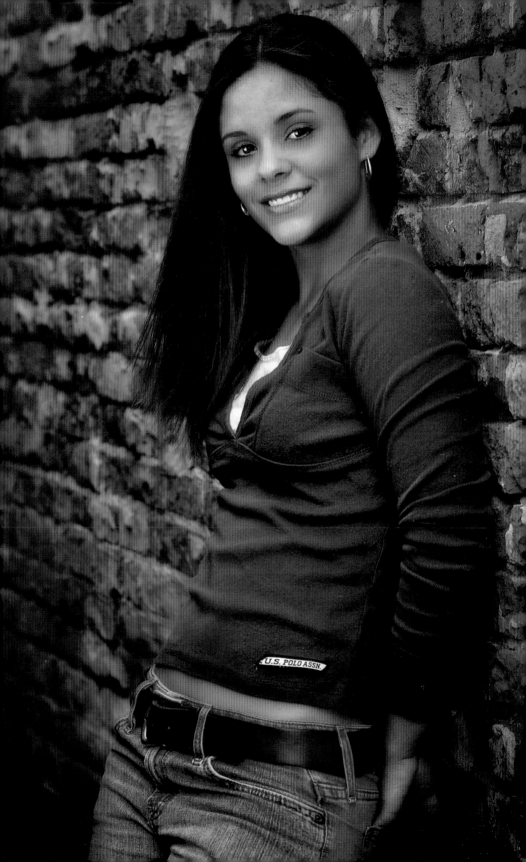

ties may be multiple. Put in writing an agreement that states how you work, get permission for events, and stipulate what you expect from the high school. Essentially, you want permission to photograph, and in turn will make pictures available to the school's yearbook if they wish. This is not a formal contract, but it will help foster mutual understanding.

Take an assistant to handle names, numbers, and money, unless you have a pay-in-advance plan. Set up a white, pale gray, or pastel background. Place a softbox where you want it as the main light, and as fill light use another softbox on a lower power setting or bounce light into an umbrella. Place small tape markers on the floor to indicate where the subjects should stand. Keep your camera on a tripod and use a zoom lens.

Couples may review their favorite poses on an adjacent computer screen and select their favorites. The nearby monitor can mean dealing with wires between the camera and the computer, so use gaffer's tape to cover wires on the floor so no one will trip on them. With a numbering system that keys pictures to couples, your postproduction work will be more efficient.

Use gaffer's tape to cover wires on the floor so no one will trip.

Keep in mind that prom pictures are important to teens whose gowns and tuxedos already make them feel special. While you will need to try to work quickly, talk to subjects to make them feel comfortable. Suggest that they temporarily ignore the audience of their peers nearby. Keep in mind that your directorial attitude and photo techniques are also on display. Even if subjects pose with gold chains on their necks or wear green dresses with pink ruffles, tell them they look distinguished or glamorous. Keep the patter going and they'll relax for these unique moments.

Photographing seniors/teens, who are in transition between youth and greater maturity, can be rewarding. Pictures you take are often saved for years to show their children. Senior portraiture can offer a meaningful career with many opportunities to please young people in a photogenic stage of their lives.

9. POST-CAPTURE WORKFLOW

○ UPLOADING IMAGES

Once your images are captured, you can upload them to your computer in one of two ways: by connecting your camera's cable to your computer, or by ejecting your memory card from the camera and inserting it into a card reader. With this task accomplished, make sure that each of the files open, then burn a CD of the unaltered files for backup. Ensuring the CD is clearly labeled (perhaps with a client number) will

This trio was pictured by Rick Ferro with the sun comfortably behind them. Rick used a Quantum flash unit with a bare bulb for lovely, even fill light.

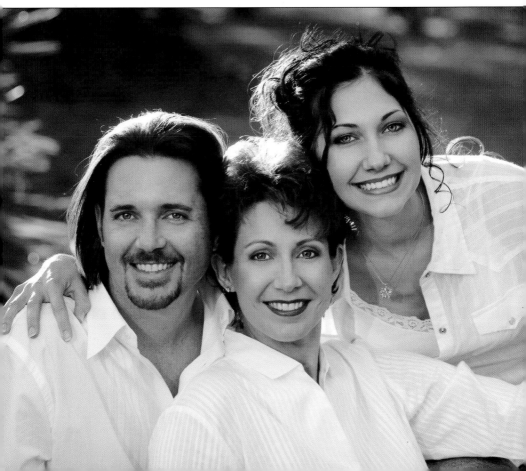

make it easy find images a client may wish to reorder down the line. Finally, test the CD to make sure it is readable and that none of the files are corrupt, then store your CD; this way, should any stage of the

David LaClaire photographed three generations of a family at home using studio flash he and an assistant set up with the main light at the left. The fill light at right was balanced beautifully, and the clients were delighted with this memorable image.

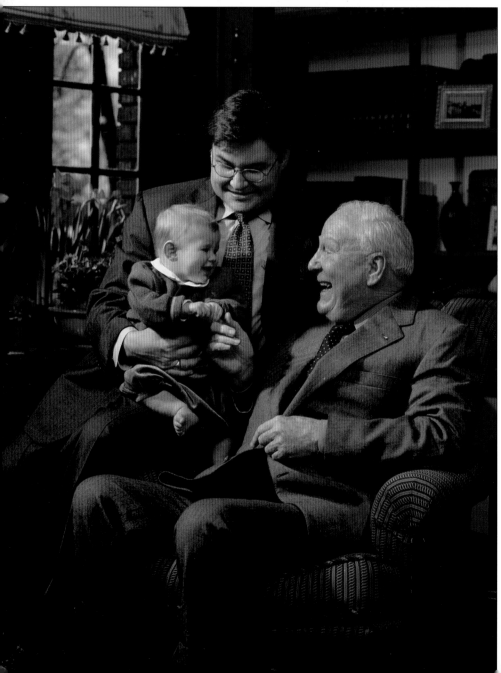

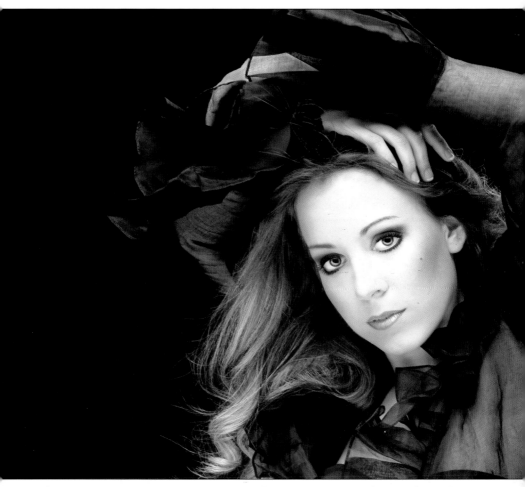

Deborah Lynn Ferro photographed this model for a client using a softbox and lots of imagination. The original was captured in color and was converted to black & white for the client. Deborah won a Fuji Masterpiece Award for her efforts.

retouching/enhancement phase of the workflow process go awry, you can always revert to your original image file.

Jeff and Kathleen Hawkins suggest bringing a laptop to a wedding and burning your pictures to a CD at intervals throughout the event. (Of course, this is good advice when conducting a location portrait session, too.) "Don't change or modify images in any way until you have first saved them," they advise. Some photographers have an assistant

back up images on location while they continue shooting on a fresh memory card. This way, what you shoot is saved and you can continue to capture pictures.

◎ IMAGE EDITING

With your original files saved and stored on a CD, you can make any necessary enhancements to the files saved on your computer. Whether you want to finesse the contrast, correct a color cast, or add creative effects like sepia toning, handcoloring, or special effects, you can use a variety of specialized software to achieve your artistic vision. Once this is accomplished, you'll want to save the image(s) then burn a new CD.

"We feature a theme portrait each month," says Frank Frost, "and this one is April Showers." The child was photographed in the studio, and the rain effect was added with a Photoshop filter. It's a fine example of using ingenuity to help boost profits.

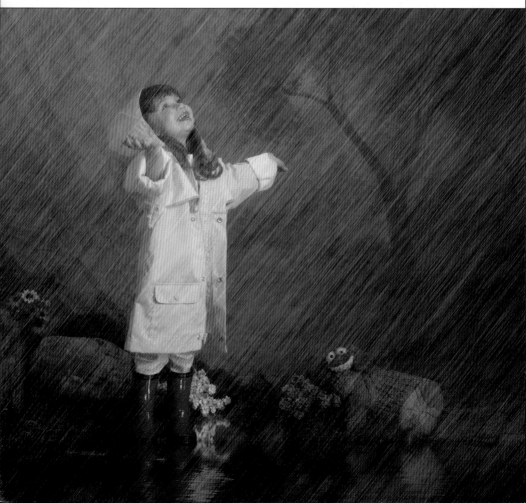

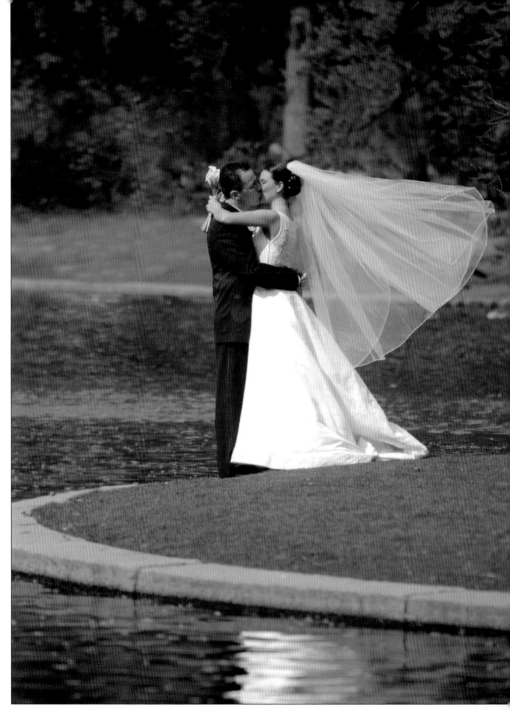

Isolated from their wedding party, an entranced bride and groom enjoyed the moment as Tommy Colbert encouraged them to do for part of his photojournalistic wedding coverage.

Frank Frost and his wife Cherie work together photographing children. The baby watched a sparkling string of beads and metal cutouts as Frank took pictures with flash diffused by his Starfish softbox.

○ OUTPUT OPTIONS

While printing options were discussed in chapter 4, printing is an important part of the workflow process. The remainder of this chapter is devoted to this concern and includes professional perspectives from top industry shooters.

In-House Printing. In chapter 5, you read about Doug Jirsa's preference for the Fuji Pictography 3500 printer, which uses photographic silver-halide paper. That printer may be expensive for the average studio, so look into inkjet printers that use durable pigment inks (check models by Epson, Canon, HP, and other manufacturers).

Professional Labs. Photographers who send their image files to a production lab prefer not to spend their time or money on printing their own images. Compared to the traditional costs associated with paying

for film, film processing, and proofs, digital workflow may save money, depending on lab fees and the cost of in-house labor. I usually find it comforting to have other professionals do my lab work. I also enjoy having pictures preserved on CDs, because they are less vulnerable than negatives.

It's probable that a lab you once used for film offers digital services. There are good digital labs all over the United States. They advertise in professional magazines like *Rangefinder*, *Shutterbug*, and *Studio Photog-*

This was among the many fine images that Brian Crain contributed to my book, and when I asked whether this was a wedding guest on one of his assignments, he said it was a portrait of himself taken by his assistant Jessica Johanningmeier. It was made outdoors with hair light supplied by nature. Brian used this neat image on his website.

raphy & Design, and they exhibit at photographic conventions. Ask other photographers for recommendations, and check lab websites to learn more about their services and prices. Services and personnel at all labs are not the same, so get advice and make comparisons. If the lab you choose provides proof prints and enlargements recorded *in* the paper rather than *on top* of it like inkjet printers do, you may not have to make large capitol outlays for an in-house printer.

PERSONAL CHOICES

For expert information about using a production lab, I talked to Steve Troup, president and CEO of Buckeye Color Lab in North Canton, Ohio. He told me that Buckeye Color Lab uses Fuji Frontier inkjet printers for volume work. "Inkjet printers have a great place in the photographic world along with photographic printing papers," he says. Here are more of Steve's views on the postproduction process:

• In the film world, workflow was relatively simple and well honed over many years. The digital world presents exciting new options for photographers. In some aspects digital is more complex than film because you must learn new computer skills and take new responsibilities. With your files on a computer you can also be better organized.

• After digital capture, decide how much work you want to do on the images. You can avoid making proofs by projecting digital images to a screen for client viewing. Handle color management and retouching on a computer in the studio or hand it off to a lab. Compare time and costs of lab proofing services vs. doing it in-house. Consider also your personal aptitudes and desires. Are you interested in photo finishing rather than shooting portraits or playing golf? Do you have or want to develop all the proper computer skills? Perhaps your employee(s) can do much of your postproduction work while you shoot.

• Proofing choices can affect sales presentations at your studio. Instead of discussing proof prints with a client, you can talk about pictures on a monitor (these are larger than paper proofs) while you and your clients are seated at a desk.

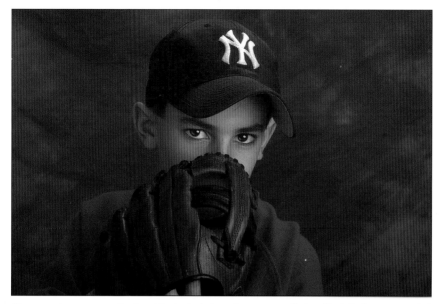

Encouraging your portrait subjects to bring along props that reflect their own special interests, here baseball, is a great way to ensure personalized portraits. Photograph by Frank Frost.

At A&I, a professional lab in Los Angeles, their principal printers are Fuji Frontier minilabs for proofs; Iris printers (or giclées) for high-quality, fine-art inkjet prints on watercolor papers; and Cymbolic Services Inc.'s Lightjet digital enlargers, which expose onto type-C paper. The Lightjet 2080 also enables photographers to create new negatives or transparencies from existing ones or from prints when negatives or slides have been lost. The printers and digital enlarger mentioned are expensive, perhaps another reason to use lab services.

Numerous other labs nationwide offer a comparable smorgasbord of printing possibilities. Check some out and ask lab managers what equipment and papers they use and why.

Dina Douglas, who photographs weddings lives in a large metropolis and is able to boost her career by handing all her postproduction work over to a lab she trusts. She explains, "I personally take my memory cards to the lab where they transfer pictures to a CD and make 4 x 6-inch proof prints of those I select, usually within twenty-four hours. Clients come to my office to make choices or I mail them proofs. The

Brian Crain photographed a lovely model, and while he was doing some postproduction work to create a pure white background, he decided to duplicate her image, flip it, convert it to black & white, and add it to the composition. It's a clever experiment that one of your clients might also enjoy.

lab does whatever touchup is necessary as part of my print order. I'm free to concentrate my weekends on weddings and my weekdays on client services and contacts." If your lab doesn't happen to be local, you can routinely handle workflow by mail, e-mail, and/or telephone.

○ PRINT DURABILITY

In Jeff Smith's *Professional Digital Portrait Photography* (Amherst Media, 2003), he says that some studio photographers are selling prints that clients expect "will last a lifetime." Jeff's lab supplies silver-halide prints he feels comfortable selling. Since Jeff's book was written, impres-

sive new inkjet printers are available, and some companies claim their prints will last fifty years or more in favorable conditions. Many printers are now priced reasonably enough for the average studio, and the best of them will pay for themselves if your volume is limited.

● DO IT YOURSELF

You may not need a production lab if your shooting schedules are adjustable and you have the interest to handle your studio's postproduction needs. The added attention you give to white balance while you are shooting can result in your pictures needing less color correction. Here are other suggestions for efficient in-house workflow:

- All studio needs are not alike, so handle as much digital workflow as suits your temperament and budget. Labs are there to help when you need them.
- Invest in a 19-inch (or larger) computer monitor for improved viewing of pictures you work on. An equivalent-size screen would serve well to show pictures to clients.
- It's necessary that you know how to work with color management profiles, which means learning to use a program like Adobe Photoshop for image enhancement. Investigate your need for related programs, called plug-ins, to facilitate some operations and special effects. A comfortable way of gaining a working knowledge of Photoshop is to hire a guru, a fancy way to say personal instructor. The money you spend will be worth the time you'll save. If you're like me, you'll also avoid the anguish of trial and error.
- Making proofs in your office will take more of your time, but there's convenience to consider. Your decision depends on the kind and volume of business you do. If you want to handle your entire workflow in the studio, master the process of color correction and invest in a high-end printer that is versatile and offers excellent image stability.
- Keep work sensibly segregated to find files easily. For example, organize originals in one folder, retouched images in another, and keep JPEGs and final TIFF files separate, too.

WORKFLOW OPERATIONS

The digital workflow process encompasses the entire range of steps that digital photographers go through to convert digital image files into prints that people love. J. D. Wacker offered the following points regarding this important process.

- One of the image formats that many photographers prefer is JPEG. In this format, the camera makes automatic adjustments (white balance, sharpening, etc.) to the captured image data. RAW mode, on the other hand, preserves unaltered all the information about a subject, allowing the photographer to make adjustments to white balance, sharpening, etc., after the shoot. The drawback to shooting in RAW mode is that it takes more space on a memory card or hard drive and may have to be converted to JPEG to print. News photographers are more likely to shoot RAW to be certain to have enough visual information to produce a successful final image.
- Before screening images saved on a hard drive for a client, photos with awkward facial expressions can be deleted. The remaining images may be enhanced to correct color, tonality, and minor flaws. Rotate images if necessary. Copy selected images to a new folder as TIFF files, and rename the file with a client work-order number.
- Portraits may be previewed on a computer screen in the studio during or after the shoot. In some studios clients may select and order images when they are screened. After a sitting you can make Quick Proofs if you wish (see page 99). At a wedding, photographers may download images from a memory card and show selected portraits on a laptop if there is time. Memory cards can then be cleared, reformatted, and made available for immediate reuse.
- To save labor in your studio, proofing can be turned over to a professional lab by sending selected images on CD via U.S. mail. Alternatively, files can be sent via the Internet using a secure lab website. You may also put selected images on your own website where clients with a password can access them, share them with friends and family, and order their favorites.
- Some photographers send all printing jobs to a lab, and others prefer to print in-house except when their in-house printers cannot handle paper larger than 8.5 x 11 inches. In that case, the whole job goes to the lab so colors match in all image sizes. Save each file at its original size and crop formats (optional). Keep all files until the client order is complete, then store them on labeled CDs in archival sleeves and delete from the hard drive.

Even though you can't see his face, the handcolored trumpet and class ring tell you a lot about this senior. Photograph by Brian King.

Well-planned workflow strategies are integral to running a successful portrait studio. Get comfortable with postproduction processes, because producing pictures is the ally of shooting them. New programs and equipment can seem daunting, but it's satisfying to discover that you can evolve in personal style and business acumen.

◉ DIGITAL HELP

A challenging aspect of going digital is mastering the workflow process. This entails knowing computer techniques to edit, save, and store images and to produce prints or slide shows to show clients. Some professional photographers prefer to use their time and talent to take pictures and manage their business and decide to hire people who are expert or at least experienced to do the important computer part of the workflow process.

A good arrangement would be to employ a skilled person part time. A friend of mine works with a man who started as his computer guru and taught him the rudiments of Photoshop and other computer skills. "I really didn't want to master all the intricacies," my friend told me. "I'm comfortable with the basics, and Paul is available with a day's notice. He

saves me time and aggravation because he's a specialist. Otherwise, when I need pictures converted for projection or enhanced for printing, I'd have to work with a manual beside me. He saves me that effort."

As you contemplate outside help, consider teenagers (your own, or students you may meet when photographing them). Many young people are computer savvy and will enjoy being paid to give you assistance. When you are busy enough shooting, part-time experienced employees can be a blessing.

10. PRESENTATION

O PAPER PROOFS

You may find paper proofs useful, even if the client has viewed their pictures on a computer monitor. If so, show the prints in pleasant surroundings, such as an area decorated with your portrait enlargements. Provide comfortable chairs at a nice table where prints may be spread out and easily viewed. Give clients time to compare, and casually help them make selections. Offer package deal information. Some photographers have

Frank Frost says about posing, "Call me old fashioned, but I feel the father should be placed in the center of a family group. It should not look rigid, and I like the subtle message that everyone is gathered around Dad. Besides that, Dad is often the one least excited about the group portrait, so I can make him feel special."

This dynamic image by Bill Abey shows how trying a new idea can somtimes have big payoffs!

found that paper proofs pay off, because clients want something to show friends and relatives.

Point out various print sizes on the wall and explain that frames on display are available. Help people choose wisely and explain that ordering additional prints now will be less expensive than later. Print out their order, make arrangements for client pick up, or delivery at no extra cost by a certain date. Explain that prints must be paid for in advance, and give a receipt.

○ DIGITAL PROJECTORS

A digital projector looks somewhat like a slide projector without the carousel on top, but with complex circuitry inside and a projection zoom lens in front. Images from a hard drive are projected by a video system to a screen on which the images appear large enough to be seen by a group of people.

Projectors can be programmed to show images for as many seconds as you choose. In addition, musical selections can be synchronized to accompany the portraits. In essence, a digital slide show is like a film slide show with much easier lap dissolves. It is a very popular way for photographers to present a series of digital images to clients at a conven-

ient time after a sitting. Projection can include enlarging, fading, text, and other graphic techniques.

Arrange comfortable seating, have your digital projector and screen ready, darken the room, and make the presentation. Talk about the special qualities of some pictures. Arrange two or more pictures on the screen for comparison. Take your time and, if there are a lot of pictures,

take a break to explain your print packages and answer questions. Following the viewing, a print order can be generated. (For tips on pricing, see page 200.)

There are a number of excellent digital slide projectors available from Canon, Panasonic, Sharp, Kodak, Sony, Viewsonic, and other compa-

As a commission from a cousin, Robert Arnold photographed Samantha. It was to be a surprise gift to her parents at Christmas. He used a softbox at the left and a Softar No. 1 filter over the camera lens.

Laura Cantrell didn't take her young subject into nature; she brought the Denny Manufacturing Company, Inc. waterfall into her studio as a photo-realistic backdrop. The rocks are also Denny props. Laura's photograph served as the cover of a Denny 2004 supplemental catalog. (Courtesy of Denny Manufacturing Company, Inc.)

nies. At this writing, prices varied from $1000 to $3000 and up, depending on the features and projection distance offered. Sharp literature, for instance, notes the possibility of screen diagonal sizes from 30 inches to 300 inches.

How you choose to present pictures will depend on your inclinations, your clientele, and your budget. It's less time consuming to make paper proofs in the traditional fashion. It's more exciting to give clients a slide show. Keep in mind that in addition to your classy photography, your showmanship and your personality add to the mix at presentation time. A sincere, cheerful attitude sells. Get as deeply involved as you can—and enjoy!

Kurt Brewer and his wife, Monique, run a portrait studio in a building on a main street in Salida, Colorado. Their display windows on the first level attract people to their second-floor studio. Kurt, with twenty years' experience in portrait and wedding photography, happily switched from shooting film with a Mamiya 645 to a digital Nikon in early 2003.

For initial experience with his new digital projection system, Kurt invited some high-school seniors to complimentary sittings. He told me, "I was immediately satisfied with the pictures I was getting. I did research before buying a neat Viewsonic digital projector. Operated by a laptop, pictures seen on a 2-foot-high white screen in our reception area are easily viewed from 6 feet or more. My test senior audiences were delighted with themselves on the screen, and they ordered a lot of prints 8 x 10 inches and larger."

During his freebie sessions Kurt worked out the kinks of his projection system as he familiarized himself with a new camera body for which he already owned numerous Nikkor lenses. He said, "I found that digital increased my postproduction time, compared to just putting proof prints in a portfolio for viewing. There's more work per client to download to the computer where I select the best images, do minor retouching, then put them in sequence to show, but our pictures have improved and our more dramatic presentations have helped boost sales by about 50 percent. Seniors especially have a positive feeling about what they see, like they were having a screen test."

○ WEBSITES

Some photographers—especially those who shoot weddings (there's more time between the event and presenting proofs presentation than there is for portrait sessions)—elect to post their best images on their websites for client viewing. Wedding couples may visit the photographer's site while on their honeymoon, enter a password, and view their images while their excitement and enthusiasm is still high. Upon visiting the site, clients can read directions for placing online orders or may indi-

cate that they want to ponder the pictures and postpone placing an online order or order at the studio upon their return home.

The couple may also give their friends and relatives the photographer's web address and their personal password so they can view and order the images too. Ask a colleague who does Internet previews for advice on posting previews online.

For more enlightenment about presentation, I asked other professionals about their methods:

Dave and J. D. Wacker
Photography by J. D. (Clintonville, Wisconsin)
This family business was started in the 1920s by Dave's father, and J. D. inherited it from his folks. His mother, Jean, often shows visitors a vin-

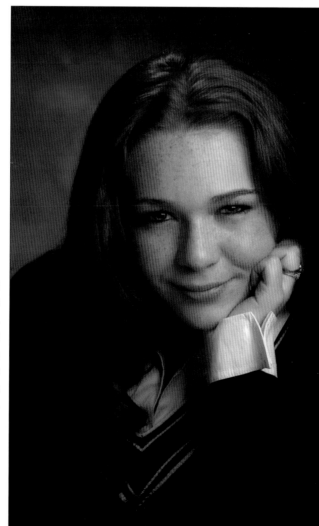

Kurt Brewer's portrait of a teen girl in a dignified pose makes her look charming. The lighting is soft, and her pretty face seems to glow against the partially dark background. Kurt's pictures are naturally popular with seniors.

Nathan 4yrs.

In the children's area of his studio, Frank Frost gave this boy a comfortable place to rest among toys. Frank's wife, Cheri, held the child's attention as Frank photographed numerous variations of this and other themes.

tage 1937 studio sales agreement that states, "The farmer has priority on the cold spring water to cool his milk before the photographer can wash his prints." Today, the Wackers use newspaper ads to thank clients by name for "helping us to create another Best of Show Portrait." They also put games and contests on their website to keep high-school seniors motivated to check studio specials.

Dave Wacker told me: "We present our images on large-screen monitors. Our best local customers require that we also give paper proofs to our high-school senior clients. These are low-resolution laser or inkjet proofs they may keep one week prior to their order date. We call them TSPs—temporary selection prints. Most of our work is sent via the Internet directly to our color lab for output on Kodak high-resolution LED/laser printers. In-house, we print promotional business head-and-shoulders pictures and special-event portraits."

A studio display board shows clients the comparison between inkjet proofs and conventional photographic paper prints. J. D. says, "The illu-

sion of impermanence has increased our sales of eight- and twelve-image permanent proof folios. Prints are sprayed with photographic lacquer to help guarantee their longevity. Introduction of our 'Retouch Lite' service (referring to basic print enhancement) gives our folios a more professional look and has added to gross sales. Clients have one week to choose the portraits they want. Longer times result in less enthusiasm. Given less time, the client feels rushed to decide."

J. D. concludes, "Show the client more than he expected and he will purchase more than he intended to buy. In a digital session we make more exposures than we did with film, and after the awkward-expression pictures are removed, seniors and their relatives will require eight to ten poses. Your order size will increase, and so will your profits."

Brian King
Hilliard, Ohio

"In 2003 we printed client proofs in-house through Photoshop as four-up contact sheets, and presented them in a 'sales' binder that included information about ordering and types of products available. For seniors we also do traditional proofing of 4 x 5-inch prints presented in an album. There's something to be said about having physical proofs in front of the client and allowing them to take them home once they've bought them after their order appointment. We now market a CD option.

"People will be enthralled watching pictures from a portrait sitting projected on a screen in a sequence you devise. We give portrait slide shows for which we use a special computer program such as Kodak ProShots (leased from Kodak), Fotoware's Foto Station, Adobe image-editing software, or Corel Painter." (Note: Kodak ProShots is a studio software suite that enables photographers to create and upload digital images to create slide shows. Photographs can also be uploaded to the ProShots website for online albums and to order proofs from a lab.)

> There's something to be said about having physical proofs.

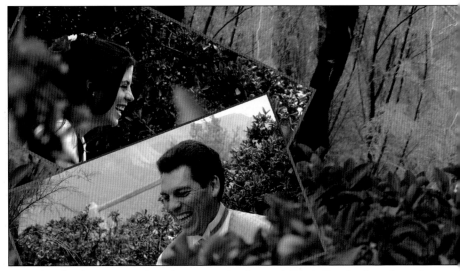

Don't be afraid to get creative when presenting images! Frank Frost's charming collage is titled *The Secret Kiss.*

Laura Cantrell

Cantrell Studio (Mobile, Alabama)

Laura is an outstanding photographer of children. She designs slide shows for parents and makes appointments for viewing. At that time they see their kids' images set to music in a theater-style room on a 5 x 9-foot screen. Custom title slides and transitions make each show unique. After the showing, Laura's sister, Lisa, comes aboard to help customers make choices. She uses Kodak's ProShots, software that allows customers to compare enlarged projected images side by side, cropped if necessary, some larger than life. "We discourage paper proofs," Laura states, "but if a customer insists or is from out of town, we use a ProShots feature to make low-resolution 4 x 5-inch images, four to a page. We charge a minimal amount for printouts and require a deposit with an order deadline of ten days.

"We've noticed a remarkable jump in sales since going to this presentation system five years ago. We're now selling a larger number of wall portraits than when we used paper proofs. Customers don't necessarily order more, they order bigger and smarter. It's a win–win situation for them and us."

*da
mi
basia
mille*

Kurt Brewer

Wild Iris Studio (Salida, Colorado)

Kurt has been a professional portrait and wedding photographer for about twenty years. He and his wife, Monique, run a modest but thriving business on a main street in the center of a relatively small town. He told me he had watched digital quality improve to a point where he could comfortably sell images captured digitally. When he bought a Nikon D100 he shot a bunch of pictures to experiment with various lighting conditions. Kurt found shooting at ISO 100 gave him digital results that were comparable to film quality.

He told me: "I bought a laptop and a neat digital projector to make images about 2-feet high on a white screen in our reception area. Using Kodak ProShots, I delete the also-rans and do minor retouching necessary on the best [images] and on others that are acceptable. Those pictures are saved to a file as a slide show. About a week after the sitting, clients come back for a screening, and I encourage them to choose their favorites. I do a final retouch on the chosen images, burn a CD, and send it to my lab with a print order.

"I schedule appointments for presentations, and parents or siblings are welcome with teens. They have an upbeat feeling, almost like they're watching a screen test! Compared to film, my work time on postproduc-

tion increased a few hours, but the images we show have improved, and the presentation is more dramatic than handing out paper proofs. Photographers switching to digital need to be conscious that more time will be spent with clients, and this should be priced into the product. Digital has helped boost our sales about 50 percent."

Kurt continues, "Congenial presentations of portrait or wedding photographs can become a miniature social event. When clients seem appropriate for it, and I want to help encourage a favorable mood and larger order, I offer cookies and soft drinks during a slide show. There's always lively conversation and enthusiasm about the pictures.

"At the end of a session when paper proofs are presented there's less time for frivolity, but I do ask some subjects, especially seniors, to join me when their pictures are coming out of the printer. I trim the four-up sheets and add the studio name and file numbers, and my 'audience' is entertained by their own images."

O PRICING

Try not to set print prices too low. Check competitors' websites, and if they don't post prices, call and ask for pricing advice. Other photographers will usually be helpful, particularly when they don't want you to undercut them. Prices that are too low might attract clientele that will buy fewer prints. By charging appropriate prices for beautiful work, you will improve your business image with a clientele that may purchase more and larger prints. Such clients are likely to recommend you to others because of your photography and the prestige that paying more creates. Save your lower prices for larger quantities of prints.

O DELIVERY

Clients may prefer to pick up finished pictures, so present them in special studio envelopes or boxes. For other orders, delivery services are routinely used. Photographer Bill Abey suggests, "Use a gift box and colored tissues" to enhance the impression of your studio and your work.

11. MARKETING

⦿ YOUR STUDIO IMAGE

Your portrait studio may already be familiar to many satisfied customers, and your success may be due to recommendations and studio promotions. Or maybe you still wonder about ways to publicize your digital portrait work. In the past some photographers worried that the public

David LaClaire skillfully arranged seven men, together with some of their equipment, in a location where they were comfortable for a picture to be used in their company annual report. With multiple subjects it is very helpful to check facial expressions immediately after making exposures. Companies can be very particular about their published images, individual and corporate.

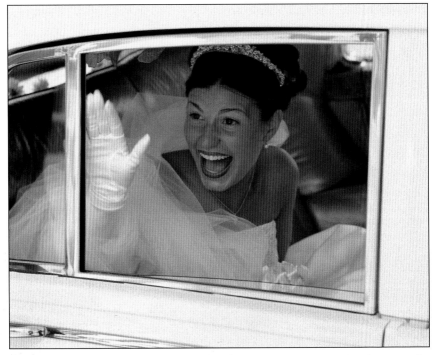

Wedding specialist Tommy Colbert is alert for spontaneous moments when a pretty bride waves goodbye to friends and relatives. Tommy meets with his couples a week before their wedding to get reacquainted and perhaps scout the wedding venue.

might equate professional digital pictures with their own point & shoot photos. Digital portrait photographers have been demonstrating their digital magic for years now, and such comparisons are no longer a concern. The public realizes that professional portrait practitioners produce classy pictures.

Digital capture is now widely recognized as an asset, and many nonprofessionals have access to very good equipment. For instance, digital printers, some of which print directly from a camera's memory card, do an excellent job. Worthy homemade 8 x 10-inch prints can be made using these printers, and families can use them for displays, as gifts, or for use in scrapbooks. But having good equipment at home does not guarantee that amateurs can produce good portraits.

Many of your clients appreciate that digital equipment in your studio is sophisticated, and they may be fascinated to view captured images on

your monitor. Though people are used to seeing their own pictures on monitors at home, the difference is they value the expert ambiance of your studio and recognize the flawless look of your digital portraits. They realize that high-end skill and quality are beyond their capabilities.

O PROMOTE DIGITAL

Consider publicizing your studio's digital capture with a phrase such as "Digital portraits at their best." Digital sells, and if people ask about your equipment, they will be comforted to know how much more complex it is than their own. Besides seeing their portraits on your monitor, fast proofs from your high-end printer will also be impressive. Even more

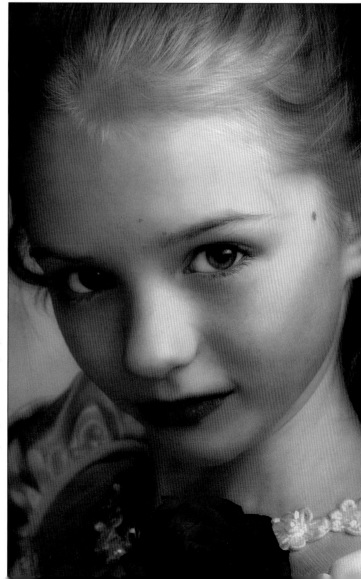

This is the type of instantly attractive image that Kurt Brewer places in his on-street window display. Kurt gave me some business tips: know your product, be aware of all your expenses, and keep profit expectations reasonable.

important, your outstanding photographs displayed in your studio are proof of your professionalism. People may recall your portraits of them on film, and digital amplifies their positive feelings.

"Digital capture will make you a better photographer," says J. D. Wacker. "We learn from our mistakes via the immediate feedback we get from seeing images just taken." Digital viewing also stimulates creativity to try different camera angles, lighting adjustments, and other changes that help improve the ways you use your talent.

O A STUDIO WEBSITE

Websites created for or by other photographers will help you realize how many pictorial and promotional possibilities the Internet offers. It is a must to have a website display of your work to spread your studio name, images, and perhaps prices widely. Hundreds of potential clients have access to the Internet, and you can invite them to view your website through local newspaper ads and other promotional means. Make your ads attractive inducements to visit your website and discover your studio.

Emphasize that clients will save money on portraits and weddings by discounts on first orders, and maybe on later orders as well. An offer of a 10-percent discount can be appealing.

> Make your ads attractive inducements to visit your website.

Study studios' websites in your vicinity and around the country. Notice their attractive designs, colors, and ad copy. A good website draws people into its pages to read about and view your portraits and senior packages, wedding coverage, or whatever you put forward. Choose eye-catching photographs that adults and teens will enjoy and envy. Change some or all of the images, and some of the copy, a few times a year to coincide with holidays and graduations and to boost summer sales. Potential teen clients will compare what they find on your site with what they see on other websites.

Unless you have the knack to design your own site, hire a website designer to do so. Good website design will give your business profes-

Bill Abey shoots many portraits for clients using Denny Manufacturing Company, Inc. painted backgrounds designed in a charming trompe l'œil fashion. Monotone is a flattering change of pace when it's warm and suits the subject.

sional presentation and pizazz, and the expense is deductible. When I write about photographers for *Rangefinder*, I learn a lot about them and their photographs from their websites. Websites reflect a photographer's taste along with the beauty of their work. They also sometimes provide a price list. View the competition's images on their websites. They can be motivational.

When you shoot digitally, you can easily update your website with new images that will appeal to your clients.

○ CHARITY PROMOTIONS

Contact several charities you want to support and offer a free sitting to the winner of a drawing that the charity undertakes. Many organizations have large fund-raising luncheons or dinners every year. Approach several and suggest they raffle tickets for a free sitting at your studio. On the

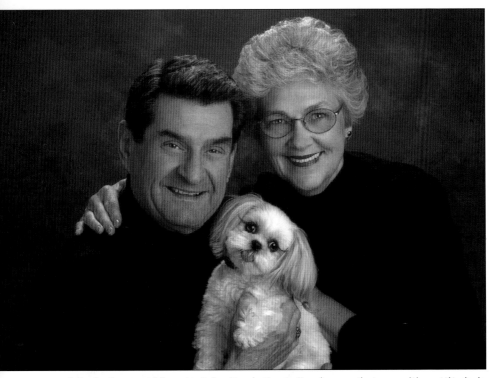

A typically graceful portrait by Frank Frost. Frank says that a positive attitude is reflected in our images and that success is also influenced by perseverance and attention to details.

day of the social event, at the hotel or restaurant where drawing tickets will also be sold, place a distinctive display of your fine portraits, along with your studio name, address, etc. If it seems appropriate, be there to encourage participation in the drawing. In this way people discover a very good photographer who is also empathetic to the charity they support. A wide audience has the opportunity to become familiar with your studio, and you can pass out cards and urge people to view your website. The winner, more than one if you choose, will promote your studio by word of mouth. A display by itself is okay, but just as important is attending the event and meeting people.

A word of caution: get written permission from people in the pictures you want to display at events and in your studio windows. Technically, you own the copyrights, but display is a form of advertising for which

you need a release in writing. Avoid the ire of anyone who might object to having a portrait shown in public.

○ PORTRAIT PLANS

Another way to encourage regular visits to your studio is by offering portrait plans for adults, teens, and children. A plan may cover a sitting each year or two at a discounted package price. The plan could also permit buyers to allow friends or family to enjoy their sitting time, and those one-timers who enjoy your services at a discount can be offered their own plans.

Photographer Laura Cantrell's Cantrell Baby Plan is designed to illustrate the first five years of a child's life, beginning as early as six weeks. The arrangement includes four portrait sessions to be completed within

Before Christmas, Laura Cantrell hires a Santa Claus and dedicates one day for "private" sessions by appointment only, offered by sending out a card with this handsome photograph on it. The setting in her studio, with lights ready, is popular and rewarding to families.

LEFT—Tim Schooler photographs a lot of seniors in the studio and on location. This was a daylight shot, with a black scrim used to block some of the light from behind the young man and a reflector placed on the right. Like so many of us, Tim is enthusiastic about shooting in the shade. FACING PAGE—This unique lighting was produced when Anthony Cava placed a large softbox off to the right with a grid spot on the girl's face. What I find unusual is the noticeable shadow, which is pleasant to see occasionally. Anthony experiments in his portraits with pleasing effects.

two to four years. A portrait is chosen and printed after each viewing, and a matching set is printed at the plan's conclusion. Additional prints can be purchased at any time. "It's a good way to wean parents to professional photography," she says.

Think of plan variations to entice clients to come to your studio for portraits on a regular basis. They save money, you make money, and word-of-mouth promotion is generated. For inspiration, look into other photographers' plans.

○ WINDOW DISPLAYS

When your studio is located on a relatively busy street, promote yourself with photographs in display windows to attract business. People may come in for a price list or information about your sittings and realize how accessible you are. Enjoy a conversation and suggest they make an appointment.

Doug Jirsa, whose studio operation was described in chapter 5, draws seniors and others to his shop by placing a monitor in each of his front studio windows. One monitor shows current specials and other business-oriented announcements, readable even when the studio is closed. The other monitor displays high-school senior photos in a continuous pres-

entation dissolving from one to another, 24/7, and it's been a great success. Since there are hundreds of images on the disc, young people wait and watch for their friends or themselves to appear. The monitor display attracts past and future subjects.

○ ADVERTISING AND PR

Paid advertising, mailers, and studio displays are all feasible promotional ideas. If your budget will sustain the expense, hire a combined ad agency and public relations (PR) firm. Ad agencies work on commission, and some prefer clients with larger ad budgets than you may have until you are more prosperous, but smaller agencies can grow as you do. It's also feasible to write and place your own newspaper ads. The advertising departments of most newspapers usually offer advice about composing

After photographing a wedding in Santa Fe, New Mexico, the newlyweds decided to walk from the church to the reception place, and Frank Frost went along. Passing through a small park, he asked them to sit on a bench where he made this picture, later converted to a panorama. Cheri Frost, Frank's wife, added the sentimental words.

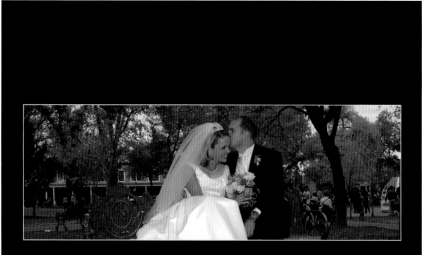

for it was not into my ear you whispered,
but into my heart.

it was not my lips you kissed,
but my soul.

Judy Garland

the kind of ads your business needs. Mention your specials. Buy as large an ad as you can afford, and run it every week for a while.

Figure out ways to get your work published. Perhaps you can persuade a newspaper or magazine to do a newsy and flattering article about you. A local premise might be that you are photographing the oldest citizens in town for the city's archives, and a reporter could go with you to cover a session. Newspapers and smaller magazines make space for such stories that help you stand out.

You may also consider having a handbill printed, such as an 8.5 x 11 page that identifies your studio and says nice things about your photography. Offer specials and a friendly message. Hire one or two high-school students to cruise parking lots and place your flyer under automobile windshield wiper blades. You can distribute them over a period of time.

To target a specific demographic, like new mothers who also may have older children at home, utilize a mailing list service to get client names and addresses, and send printed mailers to them. Devise mailers to send to your present client list, too. Ask walk-in clients how they heard about you and make use of that research.

○ OVER AND OUT

Advertise your pictorial qualities and pack your ads with easy-to-read copy and good pictures. Enter professional competitions to help prove your expertise. When you win awards, let your clients know. Remember, you don't have to be the cheapest to compete. Be the best. Show prospective clients fine examples of your portraits and they will be inclined to choose your studio over your competition. Send happy grownups and high-school seniors home as advocates for your studio. Young egos drive teens to look their best, sometimes theatrically so, and if you demonstrate a classy talent for making flattering images, they will also pay more for your services. Teens will urge their families to choose a cool photographer. Your personality and enthusiasm will help grow your business.

PROMOTIONAL IDEAS

Kalen Henderson runs a robust portrait business in Mt. Pleasant, Iowa, and leads photographic seminars. She has written two self-help publications from which she has given me permission to quote. The smaller of the two is titled *12 Money-Making Promotions for Your Photography Studio.* Here are some highlights:

- Send a card to a mailing list of high-school seniors offering a free group photo session to both card recipients and his/her friends. Limit the time frame to two or three weeks. Photograph the group, but take individual portraits as possible add-on sales. Give each teen a group picture and price packages so they can order their individual poses. Charge a small fee to fill orders. Offer free proofs as a buying incentive with orders above a certain level. When finished orders go out, include a coupon for another promotion such as a discount family session, or for reorders of a purchased pose.
- Find a "partnering" organization such as a hospital. Offer to provide a baby book for them with pictures of all the children born during a certain time span. In return ask for a list of all the babies born in the past year, and ask for lists of monthly additions. This promo could run a month or six weeks.
- Send a letter to new parents noting your affiliation with the hospital and explaining that you're photographing all newborns and that albums will be displayed in the hospital. Parents are asked to make appointments for free sessions with no obligation to purchase. One image from proofs they pay for will be included in the album. Explain that special packages and pricing will be available for pictures from the session. Price packages sensibly, and parents may buy and come back with their kids on a regular basis.

Kalen's other promotional ideas include photographing sports teams, creating grandparent days, and offering coupons for discounted prints before Christmas from previously shot negatives or digital images. Contact companies in your area and offer special-rate portraits of employees that employers can underwrite as holiday or birthday presents.

101 Great Ideas (self-published) is the title of Kalen's other book, which includes camera room hints, marketing tips, lifestyle suggestions, and equipment recommendations. Subjects include ideas for backgrounds, writing ad copy, and producing a studio catalog of product lines. Also in the book are suggestions for dealing with the public and setting goals. For more information, e-mail Kalen at khenderson@hendphoto.com.

You will think of additional marketing ideas to promote your studio, such as talking to high-school classes about how to get the most from their digital cameras, or telling high-school juniors which colleges have good photo courses. A lot of teens are interested in photography as a hobby or future profession. Be resourceful. It pays.

RESOURCES

Below, you'll find a list of manufacturers and suppliers that will prove useful as you seek to outfit or update your studio. Before you shop, consult websites and read equipment ads and articles in photographic magazines. Request catalogs and literature and make comparisons.

A&I
Photographic and digital lab services
323-856-5291
www.aandi.com

Adobe Systems
Photoshop, Elements, and other software
800-833-6687
www.adobe.com

Adorama
Large store with a variety of flash brands, including floodlights
800-223-2500
www.adorama.com

Albums Unlimited
Albums and layout services
800-625-2867
www.albumsunlimited.com

Backdrop Outlet
Backdrops, props, posing equipment
800-466-1755
www.backdropoutlet.com

B&H Photo
Large store with a variety of lighting and studio equipment
800-606-6969
www.bhphotovideo.com

**BKA—
Brandess-Kalt-Aetna Group**
Flash equipment, high-wattage quartz lights, lighting kits
800-621-5499
www.BKAphoto.com

Bogen Photo Corporation
Elinchrom flash equipment, flash meters
201-818-9500
www.bogenimaging.com

Britek

Store specializing in various brands of studio lighting and kits
800-283-8346
www.briteklight.com

Buckeye Color Lab

Lab services
800-433-1292
www.buckeyecolor.com

Paul C. Buff, Inc.

AlienBees and White Lightning studio flash
800-443-5542
www.white-lightning.com

Calumet Photographic

Studio flash units, kits, umbrellas, accessories, good catalog
800-225-8638
www.calumetphoto.com

Canon USA

Cameras, printers, scanners, digital projectors
800-665-2266
www.canonusa.com

Chicago Canvas & Supply

Backdrops in various materials
773-478-5700
www.chicagocanvas.com

Chimera

Lighting modifiers, diffusers
888-444-1812
www.chimeralighting.com

Classic Albums, Inc.
800-779-1931
www.classicalbum.com

Dell

Computers, printers, digital projectors
800-917-3344
www.dell.com

The Denny Manufacturing Company, Inc.

Backgrounds and props, free 110-page catalog
800-844-5616
www.dennymfg.com

Dyna-Lite

Studio flash equipment
800-722-6638
www.dynalite.com

DxO Optics Pro

Image-quality enhancement software
+ 33 (0) 1 55 205599
www.dxo.com

Eastman Kodak Co.

Digital cameras, printers, and software
800-242-2424
www.kodak.com

Epson America, Inc.
Printers, scanners, and digital projectors
888-569-0799
www.epson.com

Flora Professional Albums
www.floraalbums.com

Fujifilm, Inc.
Digital cameras and printers
800-800-3854
www.fujifilm.com

Hasselblad USA
Cameras
973-227-7320
www.hasselbladusa.com

Hewlett-Packard
*Digital printers, computers, and other
equipment*
800-888-0262
www.hp.com

Infocus
Digital projectors
800-660-0024
www.infocus.com

JTL Corporation
Studio flash, hot lights, and accessories
714-670-6626
www.jtlcorp.com

Konica-Minolta
Digital cameras, flash meters
888-473-2656
www.konica-minolta.com

Lexjet
Digital printers
800-453-9538
www.lexjet.com

Lowel-Light Manufacturing, Inc.
*Quartz and floodlighting equipment
and accessories*
800-334-3426
www.lowel.com

Mamiya America Corporation
*Cameras, ProFoto studio flash,
PocketWizard wireless slaves, Sekonic
flash meters*
914-347-3300
www.mamiya.com

Microtek
Scanners
310-687-5800
www.microtekusa.com

Modern Postcard
800-959-8365
www.modernpostcard.com

NAPP—National Association of Photoshop Professionals
Organization for Photoshop users
800-738-8513
www.photoshopuser.com

Nikon USA
Digital cameras and scanners
www.nikonusa.com

Novatron
Studio electronic flash
888-468-9844
www.novatron.com

Olympus America, Inc.
Digital cameras
888-553-4448
www.olympusamerica.com

Paterson Photographic Limited
Studio flash units, inkjet papers
770-947-9796
www.patersonphotographic.com

Performing Light, Inc.
Hensel Integra and Porty studio flash
877-443-6735
www.hensel.de

Photo Control Corporation
Studio flash and accessories
800-787-8078
www.photo-control.com

Photoflex Products, Inc.
Softboxes, dome reflectors, and lighting accessories
800-486-2674
www.photoflex.com

Photogenic
Studio flash units
800-682-7668
www.photogenicpro.com

Photographer's Outlet
Flash units, stands, accessories
800-831-8888
www.photographersoutlet.com

Photographer's Warehouse
Studio flash units and accessories
800-521-4311
www.photographerswarehouse.com

Photojunction
Software to create customized albums
866-757-4051
www.photojunction.com

PictoColor Corporation
Color correction and management software
952-894-6247
www.picto.com

Primera Technology, Inc.
Pro-level printers, color matching systems
800-797-2772
www.primera.com

Profoto
Lab services
612-729-4079
www.profotousa.com

RTS Inc.
Bowens monolights, studio accessories,
Bowens Esprit Digital 750 PRO flash
631-242-6801
www.bowensinternational.com

Samy's Camera
Store, digital cameras, lighting equip-
ment, and accessories
Los Angeles, California
800-321-4726
www.samys.com

SinarBron Imaging
Broncolor studio flash
800-456-0203
www.sinarbron.com

Smith-Victor Corporation
Quartz, photoflood, studio flash, kits,
and accessories
800-348-9862
www.SmithVictor.com

Sony Electronics, Inc.
Cameras
877-865-7669
www.sonystyle.com

Speedotron Corporation
Studio electronic flash
312-421-4050
www.speedotron.com

ToCad America Inc.
Flat flash panels, two sizes
973-428-9800
www.sunpak.com

WPPI—Wedding & Portrait
Photographers International
Organization, conventions, and a busi-
ness institute program
310-451-0090
www.wppinow.com

FJ Westcott
Lighting systems, backgrounds, and
accessories
800-886-1689
www.fjwestcott.com

INDEX

PORTRAIT PHOTOGRAPHER'S
HANDBOOK, 2nd Ed.
Bill Hurter

Bill Hurter has compiled a step-by-step guide to portraiture that easily leads the reader through all phases of portrait photography. This book will be an asset to experienced photographers and beginners alike. $29.95 list, 8½x11, 128p, 175 color photos, order no. 1708.

MASTER POSING GUIDE
FOR PORTRAIT PHOTOGRAPHERS
J. D. Wacker

Learn the techniques you need to pose single portrait subjects, couples, and groups for studio or location portraits. Includes techniques for photographing weddings, teams, children, special events, and much more. $29.95 list, 8½x11, 128p, 80 photos, order no. 1722.

PROFESSIONAL
DIGITAL PHOTOGRAPHY
Dave Montizambert

From monitor calibration, to color balancing, to creating advanced artistic effects, this book provides those skilled in basic digital imaging with the techniques they need to take their photography to the next level. $29.95 list, 8½x11, 128p, 120 color photos, order no. 1739.

DIGITAL PHOTOGRAPHY
FOR CHILDREN'S AND FAMILY
PORTRAITURE
Kathleen Hawkins

Discover how digital photography can boost your sales, enhance your creativity, and improve your studio's workflow. $29.95 list, 8½x11, 128p, 130 color images, index, order no. 1770.

POWER MARKETING FOR WEDDING AND PORTRAIT PHOTOGRAPHERS
Mitche Graf

Set your business apart and learn how to create clients for life with this comprehensive guide to achieving your professional goals in wedding and portrait photography. $29.95 list, 8½x11, 128p, 100 color images, index, order no. 1788.

MASTER LIGHTING GUIDE
FOR PORTRAIT PHOTOGRAPHERS
Christopher Grey

Efficiently light executive and model portraits, high and low key images, and more. Master traditional lighting styles and use creative modi-fications that will maximize your results. $29.95 list, 8½x11, 128p, 300 color photos, index, order no. 1778

MORE PHOTO BOOKS ARE AVAILABLE

Amherst Media®
PO BOX 586, BUFFALO, NY 14226 USA
(800)622-3278 or (716)874-4450, Fax: (716)874-4508

INDIVIDUALS: If possible, purchase books from an Amherst Media retailer. Contact us for the dealer nearest you, or visit our web site and use our dealer locater. To order direct, visit our web site, or send a check/money order with a note listing the books you want and your shipping address. All major credit cards are also accepted. For domestic and international shipping rates, please visit our web site or contact us at the numbers listed below. New York state residents add 8% sales tax.
DEALERS, DISTRIBUTORS & COLLEGES: Write, call, or fax to place orders. For price information, contact Amherst Media or an Amherst Media sales representative. Net 30 days.

All prices, publication dates, and specifications are subject to change without notice. Prices are in U.S. dollars. Payment in U.S. funds only.

WWW.AMHERSTMEDIA.COM
FOR A COMPLETE CATALOG OF BOOKS AND ADDITIONAL INFORMATION